industrial interiors

OFFICES

RotoVision

First Published in Singapore by
Page One Publishing Private Limited
20 Kaki Bukit View, Kaki Bukit Techpark II
Singapore 415956
Tel: +65 6742 2088
Fax: +65 6744 2088

ISBN 2-940361-04-5

First Published in the UK by
RotoVision SA
Route Suisse 9
CH-1295 Mies
Switzerland

RotoVision SA
Sales & Editorial Office
Sheridan House
114 Western Road
Hove BN3 1DD, UK
Tel: +44 (0)1723 727268
Fax: +44 (0)1273 727269
Email: sales@rotovision.com
Web: www.rotovision.com

10 9 8 7 6 5 4 3 2 1

Editorial/Creative Director: Kelley Cheng

Art Director: Jacinta Neoh

Sub-Editors/Writers: Hwee-Chuin Ang, Narelle Yabuka, Ethel Ong

Designers: Chai-Yen Wong, Sharn Selina Lim, Soo-Shya Seow

Editorial Coordination & Text
(in alphabetical order):
Anna Koor (Hong Kong, China)
Masataka Baba (Tokyo, Japan)
Meng-Ching Kwah (Tokyo, Japan)
Reiko Kasai (Tokyo, Japan)
Richard Se (Kuala Lumpur, Malaysia)
Savinee Buranasilapin (Bangkok, Thailand)
Thomas Dannecker (Bangkok, Thailand)

OFFICES

Phyllis M. Peirce
Fund

contents

contents

introduction

Office design is one of the most rapidly changing and exciting areas of architecture and interior design. Buoyed by major changes in the organisational structure of corporations, as well as the new working methods facilitated by advances in technology and communication, office culture and office design have dramatically altered in recent years. Many corporations are beginning to flatten their pyramidal managerial structure, and are instead developing a more singular egalitarian plane where there is more opportunity for teams of staff to learn from and inspire each other.

Furthermore, the way we view our jobs has changed along with the way we do them. Whilst the workers of just a generation ago sought a job that they would keep for life, today's workforce expect multiple changes of job, and perhaps even a change of career over their lifetime. Work is increasingly being regarded as part of lifestyle.

The adoption of machines and, in particular, the computer, to do much of yesterday's number crunching means that corporations now seek more specifically skilled workers to breed effectiveness and innovation in the work place. Attracting and keeping the best, most effective workers, requires an office space that is both inspirational and motivational; one that allows staff to interact, to be comfortable, and one that encourages them to achieve their personal best.

The new workspace is typically emerging as a "landscape" that facilitates collaboration, and through which staff can travel and interact using the new found mobility provided by the mobile phone and the laptop. Many corporations are also discovering that the embodiment of their brand image, product or philosophy in the office design is an effective way to furnish employees with a level of confidence in the business, as well as reinforcing the company image and values to clients.

This book presents some of the most exciting examples of office design to be found in Asia – a region that seems to continually experience growth as its economies develop and surge ahead in the world market. Through rich colour photographs and descriptive and analytical text, *Within Offices* showcases over forty offices from around the Asian region, which range from a cafe for freelancers in Tokyo that contains a photocopier, desks and fax machines, to a communications company's Singapore office, which contains a cave-like conference room. Reflective of today's new ways of working, the workspaces presented here illustrate just how dramatically the design of offices has developed in recent years, and indicate the exciting direction that working will take into the future. Get your laptop ready!

HIGH-IMPACT MEDIA

bloomberg

This office for Bloomberg had to mean more than functional premises for gathering and reporting news. Being able to perceive the dynamics of a complex, premier global news organisation was the key to providing the physical infrastructure to support and enhance the way Bloomberg conducts its business.

NAME OF OFFICE **BLOOMBERG**
OWNER/CLIENT **BLOOMBERG LP**
ARCHITECT/DESIGNER **M MOSER ASSOCIATES**
PHOTOGRAPHER **VICTOR LAM PHOTOGRAPHY FOR M MOSER ASSOCIATES**
TEXT **ANNA KOOR**
LOCATION **CENTRAL, HONG KONG**

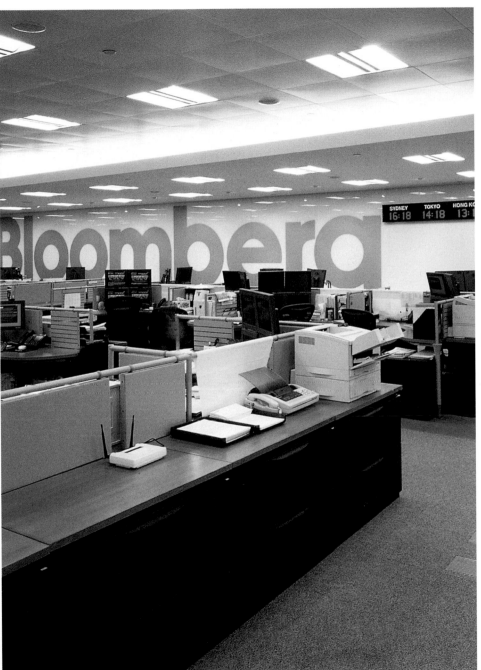

According to its designers, M Moser Associates, the inspiration for designing a workplace for Bloomberg stems from the simple equation that "information plus people equals news". News is the outcome of research, analysis, interpretation and collaboration, delivered through vivid, high-impact modes and media. Bloomberg's goal is to serve as an effective channel between people and information. These values guided every decision in the design of Bloomberg's Hong Kong office. Hence, the office embodies the idea of "news" and the essence of Bloomberg's corporate culture – energy, transparency, openness and equality.

The workplace is open and non-hierarchical, containing two broadcast studios for both television and radio, a comprehensive technology training studio that accommodates up to 35 individuals simultaneously and Asia's first Presentation Centre which functions as a training room, presentation hall and press briefing centre for 150 persons. Common distinctions such as front-of-house and back-of-house vanish. Whereas the pantry often gets relegated to an awkward corner by the stairwell, the cafe at Bloomberg's offices is distinctly visible from the entrance, along with stacks of energy-yielding bananas and power-bars. In the open office environment, staff are closely knit in universal-sized workstations, simulating a dealing-room atmosphere fired up with electricity. There's an intricate web of transparency to the array of work, meeting areas and circulation paths that are intermingled with broadcast studios, and technology-training facilities.

Reception areas serve as pantries that become meeting spaces. All typically delineated volumes are dissolved in a fluid continuum of multi-functional, spontaneous and energised space. Directors, editors, reporters, administrators, interns – all Bloomberg staff enjoy the same spatial and experiential privileges. This egalitarian approach to work is reflected in the office configuration. Permeable spaces make sharing and collaboration a natural mode of interaction, while open views and transparent thresholds create a common zone that objectifies information tasks and reinforces the public aspect of news service.

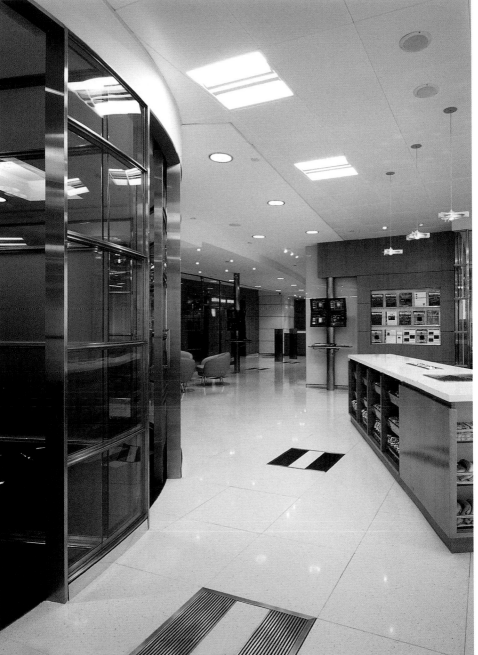

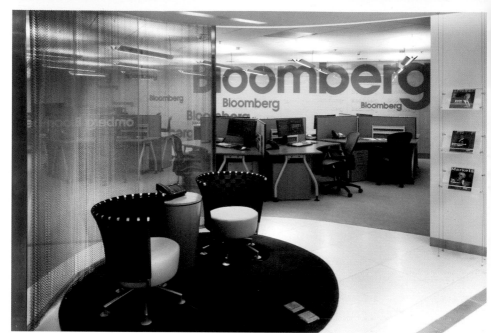

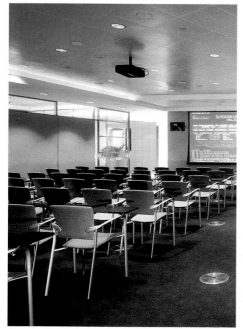

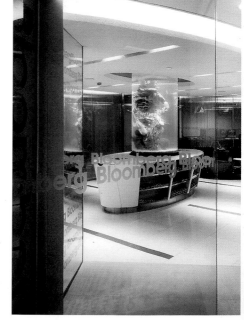

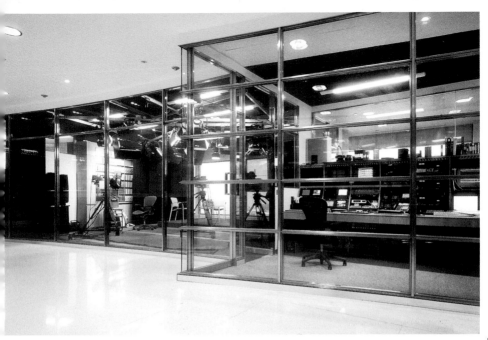

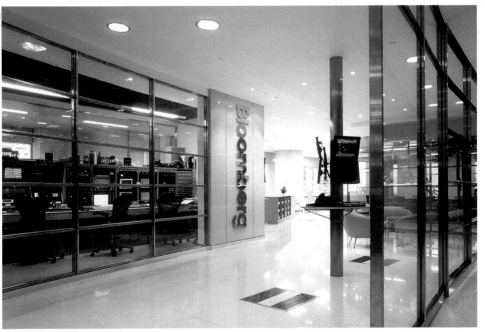

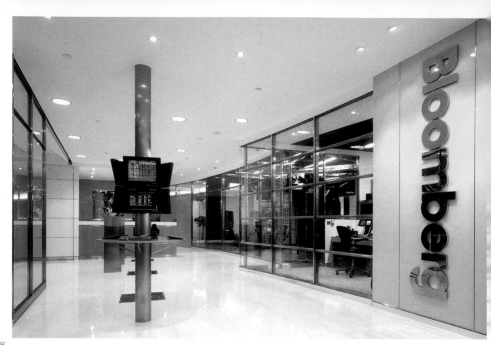

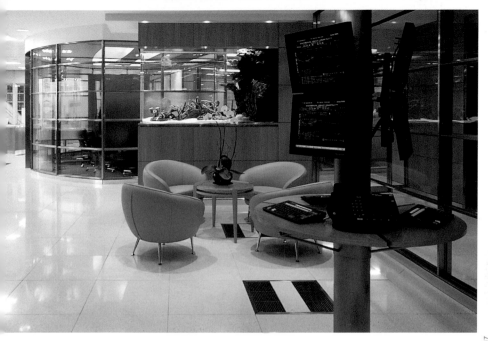

TRAVEL IN STYLE

british tourist authority

This office-cum-tourist information centre is a refreshing departure from the paradigmatic stamp that travel agencies are usually associated with. Airy and cozy, this is a place where visitors will find travelling information with ease.

NAME OF OFFICE **BRITISH TOURIST AUTHORITY**
OWNER/CLIENT **BRITISH TOURIST AUTHORITY**
ARCHITECT/DESIGNER **TONY CHAN/CREAM DESIGN + ARCHITECTURAL PLANNING (HONG KONG)**
PHOTOGRAPHER **KELLEY CHENG**
TEXT **CATHERINE CHEUNG**
LOCATION **CAUSEWAY BAY, HONG KONG**

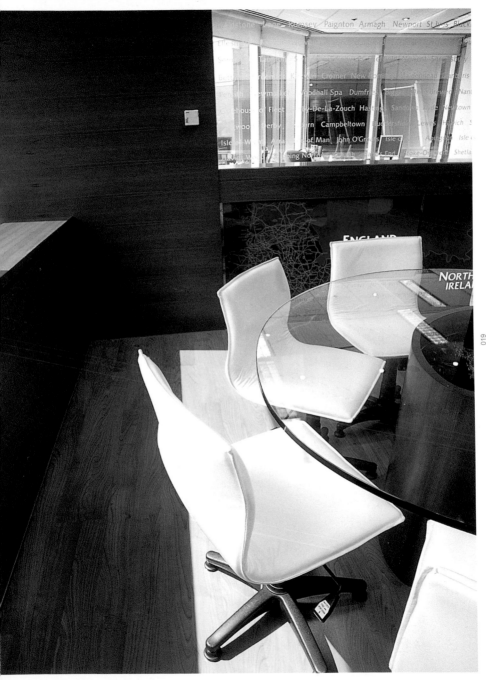

019

The 1000 square foot space functions as an office for the staff of the British Tourist Authority, as well as an information centre for travellers heading to Britain. The programmatic concern alone was a challenge with regard to the small useable space. The fact that the client was a government bureau added to the equation certain sets of corporate guidelines to which the designer had to strictly conform.

The linear form of the office has been segregated into two halves, one containing the general office and Manager's room, the other being intended for public use with a conference room and reception foyer full of both tangible and intangible travelling information. The most crucial problem of the tight floor plan was skillfully alleviated by making use of transparency and layering. The use of an open plan, coupled with expansive glazed partitions, allows maximum transparency. Defying the archetypal images that most travel agencies conjure up, this approach imbues the office with an air of total honesty, in the sense that nothing is hidden out of sight. An indoor garden encased in glass forms the visual and spatial focal point of the office, while diverting the visitor's attention away from the actual small size of the space.

The second issue of corporate guidelines was again handled with ease. Blue is the British Tourist Authority's corporate colour, and it has been liberally applied via the carpet, information desk and door handles. Visual geographical references to Britain exist in a myriad of forms, such as maps and posters of landmarks on vertical surfaces. Glass partitions are sandblasted to depict the names of different counties and towns in Britain. Even the kidney-shaped conference table is inset with a geographical map of Britain, lit from below, that negates the need to hang unsightly maps. These are cases in which purely functional elements have been elevated to a new level to become spatial embellishments as well.

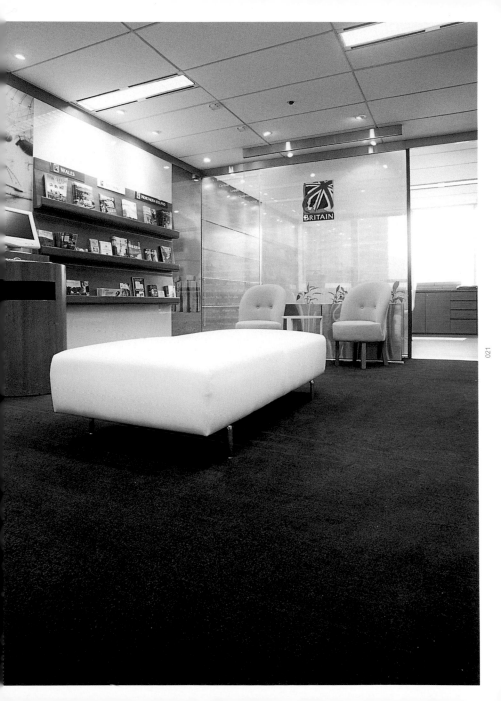

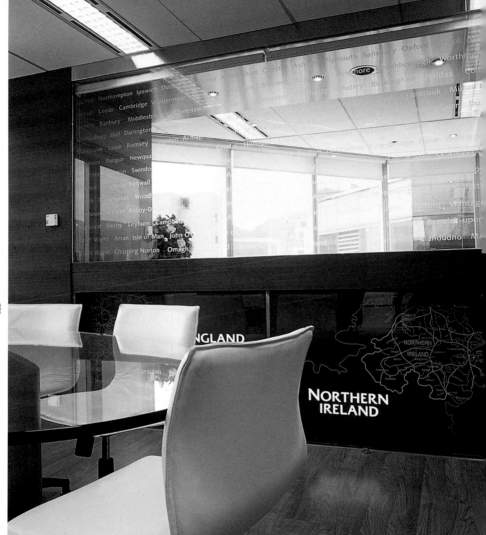

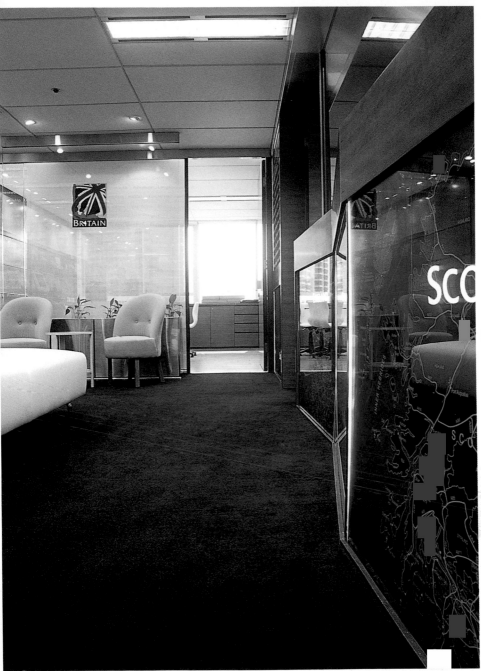

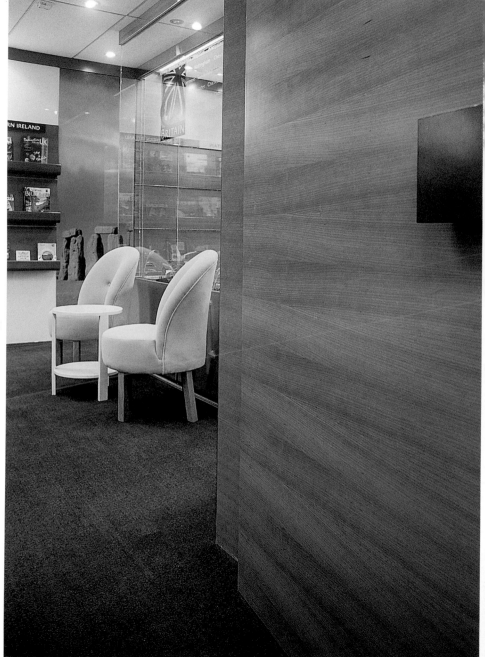

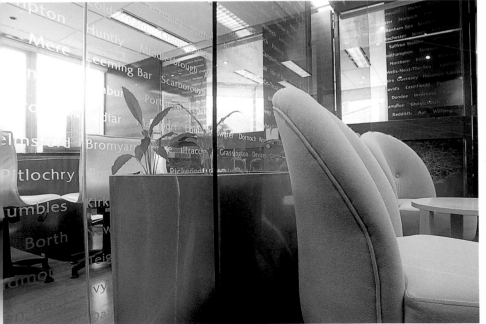

PROFESSIONALLY NEUTRAL

executive centre

This international corporate business centre offers flexible leases to companies requiring short-term office accommodation. The designers were asked to provide a professional and international corporate image through well-planned and well-managed facilities.

NAME OF OFFICE **THE EXECUTIVE CENTRE**
OWNER/CLIENT **THE EXECUTIVE CENTRE**
ARCHITECT/DESIGNER **WOODS BAGOT ASIA**
PHOTOGRAPHER **MARCUS GORTZ**
TEXT **ANNA KOOR**
LOCATION **CENTRAL, HONG KONG**

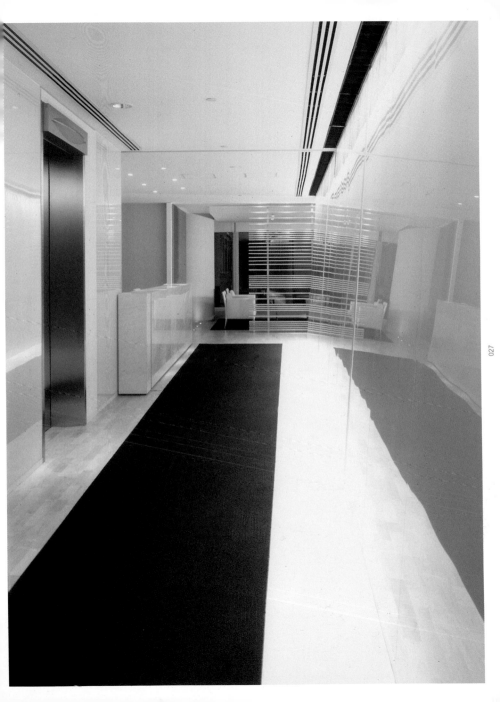

This 17,750 square foot international corporate business centre has a specific mission: to offer quality unit space and support facilities to clients looking to expand or contract their businesses in the region. The centre offers the advantage of flexible, short-term leases. Besides its prestigious address and image, companies might be attracted to the centre as a means of opening their first office in Asia, as an interim space to use whilst a full office is being established, or as a base from which to enter the China market.

There is space for 52 businesses plus six virtual units that operate as touch-down points for companies who might fly in for a few days. There are also four meeting rooms – two of which open up into a 12-person conference room – and a 30-person capacity training facility. Perimeter areas with views to the harbour are allocated to the client companies, whilst support spaces and shared resources are located in centralised accessible locations for equitable access. A menu of three variously-sized units is generically planned with the flexibility for users to configure and personalise their environments to suit the particular needs of their business.

Rather than enforcing any definitive style, the colour palette and general ambience are deliberately neutral, as this is home to several different firms as opposed to one. Strong design statements and overt signage are avoided, as they could potentially conflict with the corporate image of the diverse clients. Glass, pale-coloured sandstone and sycamore lighten up the spaces, whilst timber slatted-screens provide semi-privacy, differentiating zones without cutting them off.

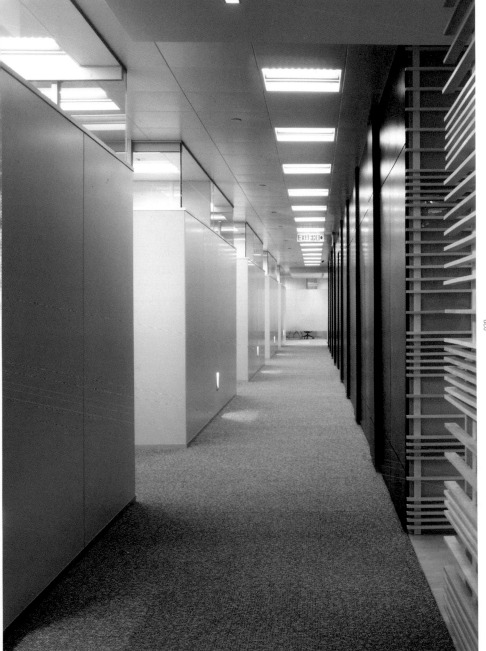

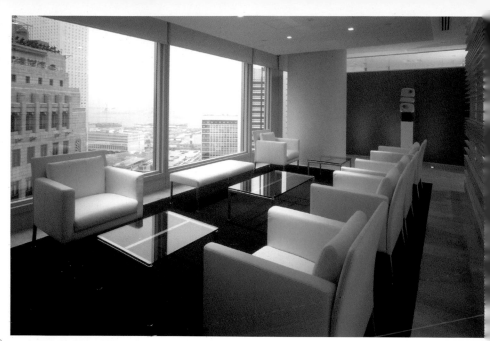

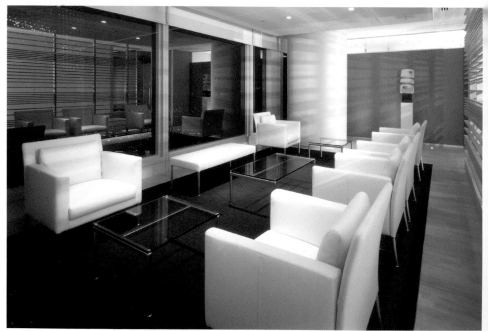

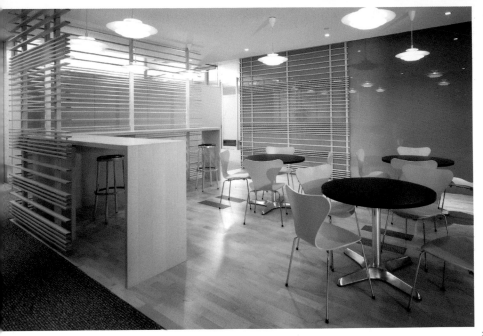

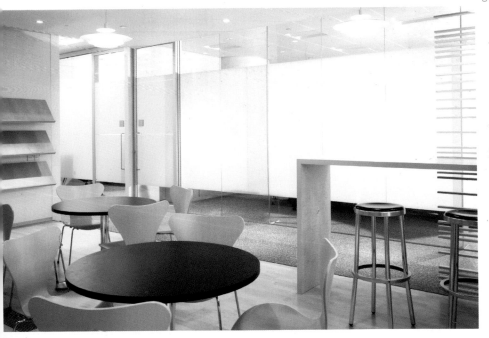

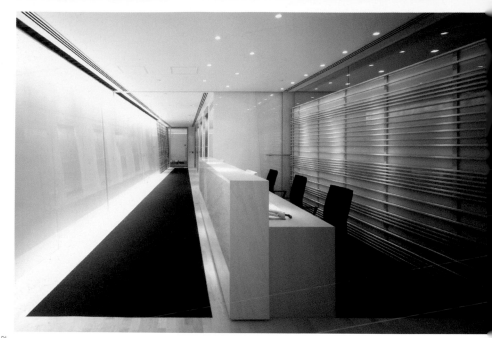

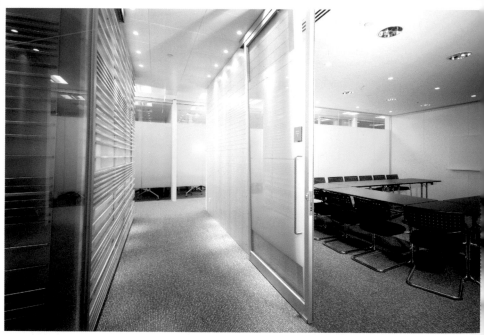

BRAVERY IN BUSINESS

fujian bank

Conducting business on the world stage requires an image that is clean, modern and forward-thrusting. Considering how conservative the banking profession can be, the treatment of public spaces at Fujian Bank is remarkably brave.

NAME OF OFFICE **FUJIAN BANK**
OWNER/CLIENT **FUJIAN BANK**
ARCHITECT/DESIGNER **L & O ARCHITECTS**
PHOTOGRAPHER **JOLANS FUNG**
TEXT **ANNA KOOR**
LOCATION **SHANGHAI, PEOPLES REPUBLIC OF CHINA**

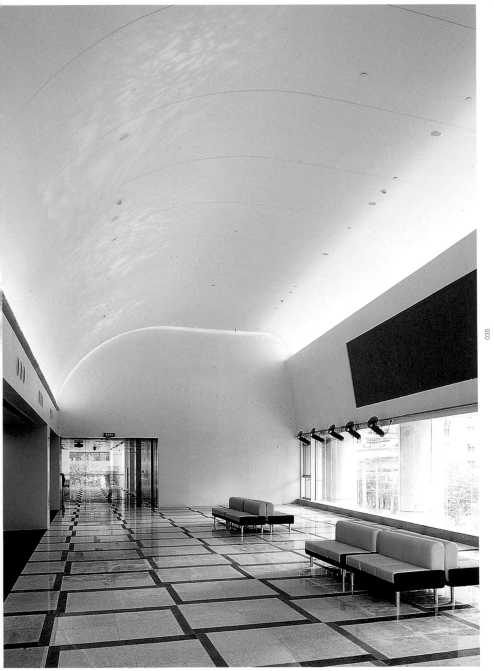

The Fujian Bank occupies seven storeys of an office building, and includes a banking hall, a safe deposit chamber, conference rooms, executive suites and general offices. Glass, panels of metal, and stone finishes define a set of truly streamlined volumes that do not fall short of contemporary. However, from the public spaces below to the general offices above, there is a transition in material usage, progressing from more hard-edged finishes to a softer, warmer palette.

A collaborative initial design process established a clear brief outlining the inter-relationships between various functional spaces. The challenge was then to accommodate limitations in terms of materials and construction skills. The architect adopted strategies to cope with this, such as a method of detailing that is more forgiving than would normally be considered. Although space is a premium, it is not bound by the same constraints as it is in other parts of Asia. This gave the architect more freedom to play with scale and proportion. On the ground floor, the bulky structural elements of the lift lobby are broken down by the use of material and light. The lift cores are cloaked in back-lit coloured glass and aluminium slats. The materials run through the ceiling junction to the floor above. A chequerboard floor, patterned in three types of granite, is deliberately mis-aligned in order to give the floor a sense of movement. The architect did not want a look that was geometrically regimented, however, being a bank, it still required a modicum of order.

Soaring floor-to-ceiling heights enabled the creation of an upper gallery that is overhung by an elliptical ceiling. The first-floor banking hall is identified by an asymmetrically coved ceiling that is completely absent of adornment, bar subtle streaks of fluorescent colour and patterns of reflected light that are projected onto it. The movement of light can be read from the street at night. Although this is a banking hall in the traditional sense, with tellers and central islands of furniture, the ambience is less harsh and glaring – a desire on behalf of the architect to make this a place more conducive to conducting business.

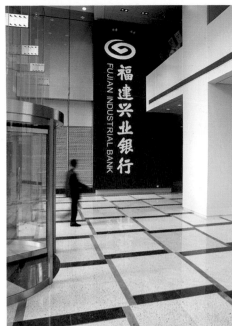

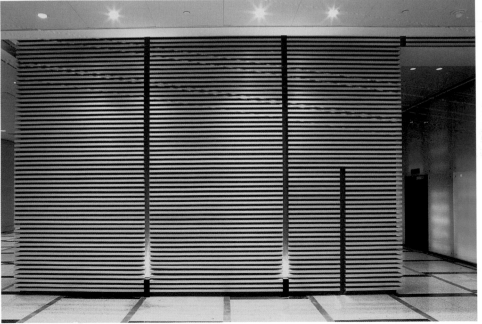

ALTERNATIVE TECHNOLOGY

henderson data centre

This workplace is a reflection of the technologically advanced nature of the business being conducted in it. With no straight walls, and a minimal use of metal and glass, the designers have produced an alternative conception of technology.

NAME OF OFFICE **HENDERSON DATA CENTRE**
OWNER/CLIENT **HENDERSON LAND**
ARCHITECT/DESIGNER **RAD IN ASSOCIATION WITH EDGE ARCHITECTS LTD**
PHOTOGRAPHER **BLOW UP STUDIOS/GARETH BROWN**
TEXT **ANNA KOOR**
LOCATION **SUN PO KONG, KOWLOON, HONG KONG**

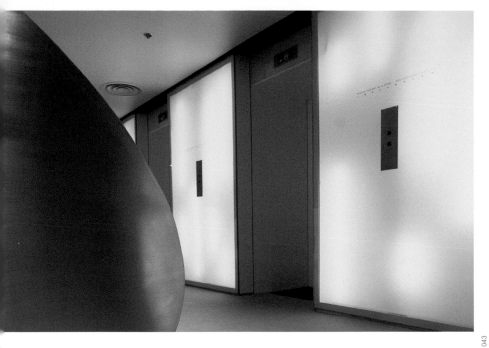

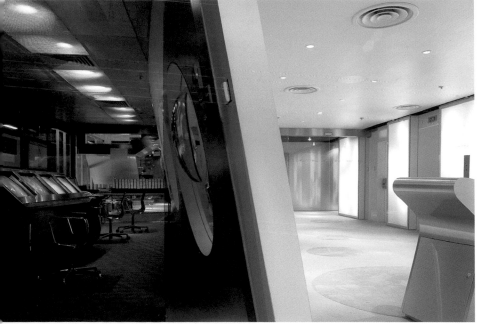

A relatively recent phenomenon in Hong Kong, data centres are shaped by one overriding function – that of securely storing information on behalf of any number of private clients. Banks of computer terminals are placed under lock and key, with the utmost consideration given to tight security. The designers were asked to be creative and produce something alternative with a strong image. Since clients are able to view the environment where their precious data is being stored, the designers decided to present the space like a showcase. Racks of computers are displayed from behind a glass wall, which is punctuated by five giant fishbowl-effect lenses. These lenses stem from the idea of being able to see into the future.

Lateral thinking was required in terms of a design that is futuristic, and the result is a smooth enclosure that is reminiscent of a spaceship. The designers chose to represent technology as something warm and sensuous rather than cold and hard-edged, so there is little in the way of metal and glass. The various functions, such as the staircase, conference and meeting spaces, are integrated within the plaza-style reception area, rather than being isolated in remote pockets. They are housed in amorphous-like cocoons that "float" around the space. There are no straight walls; spaces are tapered and skewed in different directions. Other elements are also objectified, such as the fibreglass reception counter and the technology station – a steel sculpture in the middle of the room.

A subdued yellow hue penetrates the plaza, which is strengthened in the general office area with vibrant yellow screens of translucent glass. Even here, the bulging outer wall is a link to the adjoining ovular conference room. A dazzling white space inside is contrasted by jet-black furniture and black painted glass.

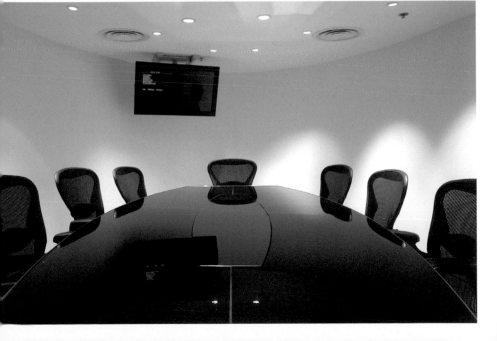

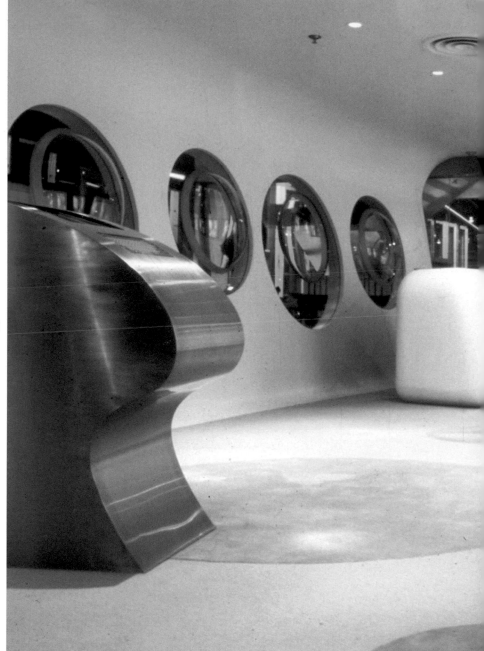

LABORATORY FOR FREE THINKING

ideal systems

Ideal Systems is a group of inventors and techno whizzes, who design telecommunications platforms, satellite station infrastructures and television broadcast systems. The brief given to KplusK Associates was to create an invigorating laboratory for the exploration of free thinking.

NAME OF OFFICE **IDEAL SYSTEMS**
OWNER/CLIENT **DECLAN COLEMAN, JIM BUTLER/IDEAL SYSTEMS LTD**
ARCHITECT/DESIGNER **KPLUSK ASSOCIATES**
PHOTOGRAPHER **GRAHAM UDEN**
TEXT **ANNA KOOR**
LOCATION **CENTRAL, HONG KONG**

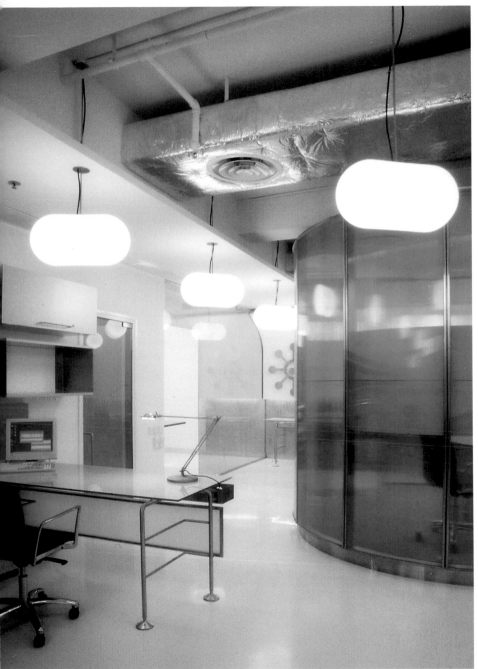

Ideal Systems' 1,800 square foot studio in Wyndham Street is relatively open in plan and egalitarian in terms of management structure. The interior is oriented around two circular "bins", one of which is a meeting space and the other of which is the private office of one of the directors. However, even the latter is multi-purpose, being used as a hot-desk environment for anyone who requires quiet space. The two pods are regarded as elements that attract and repel each other in a dialogue within a very clean space. Materially they are quite different, one being an enclosure of blue and white polycarbonate, and the other being wrapped in a high-density ribbed cardboard. They also vary acoustically; one has a long reverberation time – a "ping" and echo ambience – whilst the other is "dead" and clad in sound absorbent Sonex panels. This is used for complete privacy for activities such as conference calls, or simply letting off steam.

Around these two primary hubs, the interstitial spaces are inhabited by mobile workstations, a library and administration zones. A standard desking system was devised in consideration of economies of scale, with the addition of vanity panels and integrated cable trays. Other essential accessories for the modern office include galvanised steel sheet, which is used as a magnetic pinboard, and wipeable "whiteboard" in the form of back-painted tempered glass in the pods. The conference room is tucked away around the corner of the L-shaped plan, and delineated by a yellow laminated glass screen. The Sonex forms a textured backdrop that curves around unsightly beams and conceals cabling and other services.

The self-levelling white resin floor enhances the clean white impact and provides a seamless surface for the various elements to float off or be anchored to. A gridded pattern of overhead lighting is augmented by individual task lighting. The lozenge-shaped suspended "pill" lights were customised from Tom Dixon originals. Each is phosphorescent, creating a soft green afterglow when switched off.

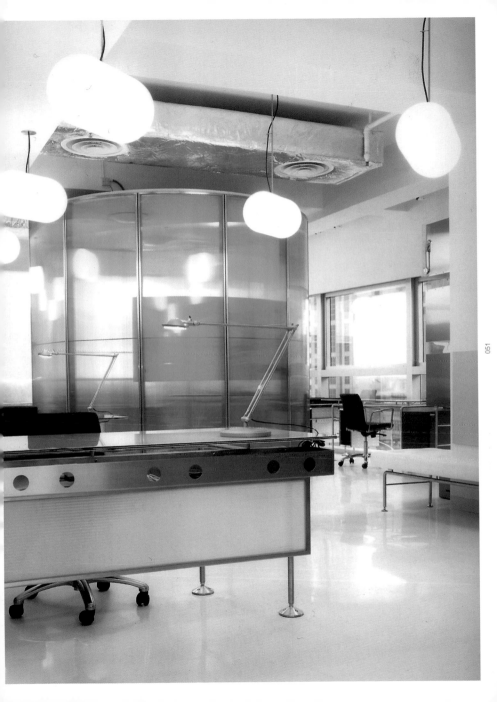

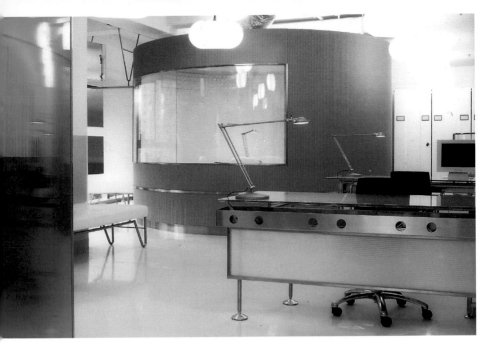

DEMOCRATICALLY DESIGNED

ion global

Ion Global is an international e-corporation whose byline is "strategic e-business integration". Its leaders were looking for something quite different from the stereotypical corporate environment for their office in the Citicorp Centre.

NAME OF OFFICE **ION GLOBAL**
OWNER/CLIENT **ION GLOBAL**
ARCHITECT/DESIGNER **DIALOGUE LTD**
PHOTOGRAPHER **ANDREW CHESTER ONG**
TEXT **ANNA KOOR**
LOCATION **CAUSEWAY BAY, HONG KONG**

Ion Global's core values – "community, creativity, excellence, passion and professionalism" – demanded an interior that communicated the same message. The designers have provided a clear delineation between public and private zones, but unlike many offices, where special treatment is reserved for the reception and associated functions, at Ion Global nothing is relegated to back-of-house. Equal weight is applied to both in terms of budget and innovation, with a seamless transition from the red perspex reception desk and spacious lobby to the general offices and collaborative spaces. The latter are given identities such as the "War Room" – a think tank area where strategists gather with their clients to map out ideas.

The square floor plate is carved into a series of hubs, which are situated against the central services core of the building, leaving the offices open to lap up the natural light. Small niche areas act as breathing spaces between a flexible configuration of furniture. Hot-desks are integrated into the general work environment, rather than being isolated in a separate zone. Therefore, each cluster of desks is equipped with one or two extra workstations that front onto the circulation path.

Colour is applied to those functions that wrap around the central core, and these include only four cellular offices. These are not a measure of status but are reserved for staff who need enclosure – legal counsel, human resources, and so on. A generous cafe and lounging area on the lower floor feels like a sun-deck with its floor-to-ceiling slanted windows. It is also integrated into the office environment, with several meeting spaces butting onto it. Interactivity and spontaneous exchange is encouraged by countless whiteboards covering every available vertical surface, including the reverse side of sliding doors and back-painted glass walls.

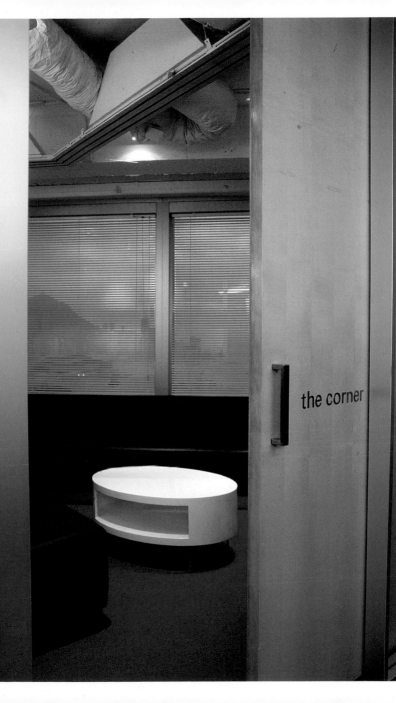

the corner

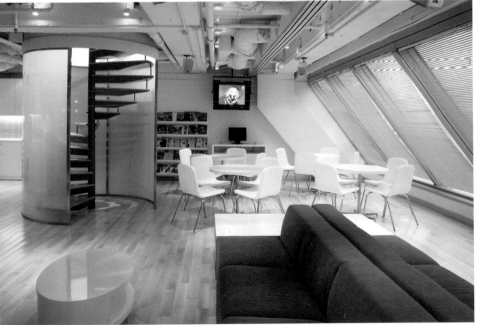

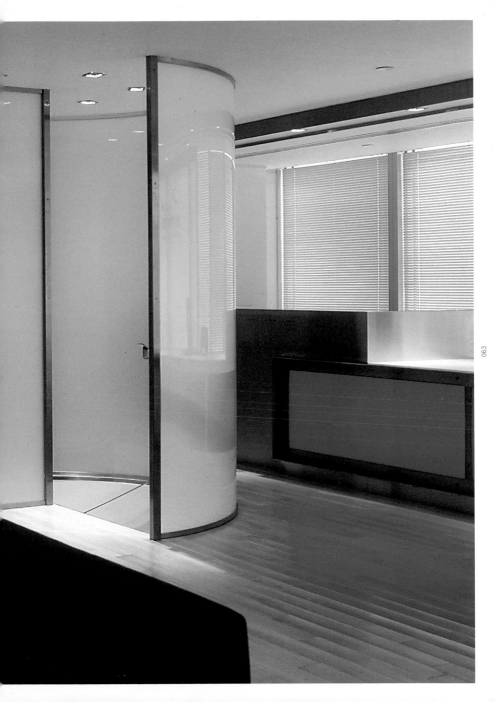

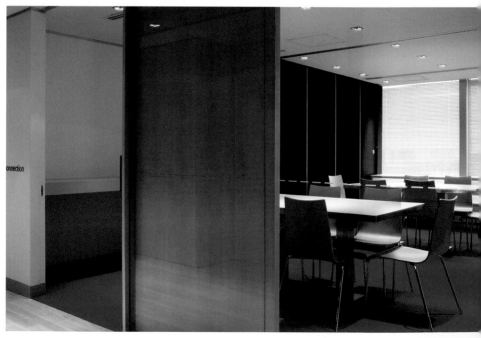

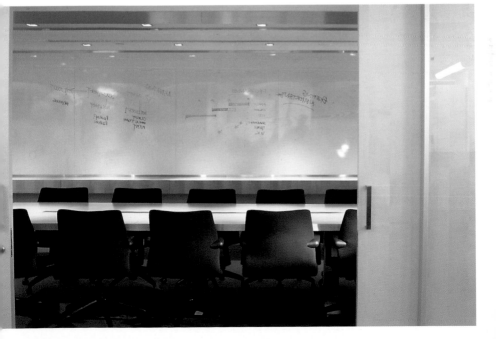

AN IDENTIFIABLE INTERIOR

lianqi trade development co ltd

Unison Enterprises, a leading supplier of raw material to the global garment trade, required an office that conveys the image of a well-organised, modern, international operation.

NAME OF OFFICE **LIANQI TRADE DEVELOPMENT CO LTD**
OWNER/CLIENT **UNISON ENTERPRISES LTD**
ARCHITECT/DESIGNER **SUNAQUA CONCEPTS LTD**
PHOTOGRAPHER **KEN CHOI**
TEXT **ANNA KOOR**
LOCATION **ZHANGJIAGANG, PEOPLES REPUBLIC OF CHINA**

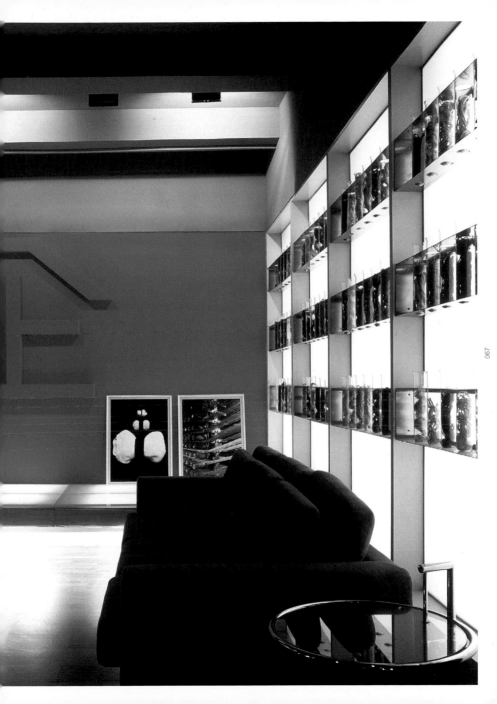

Unison Enterprise has a high-profile client base of global brand name apparel labels. It also faces tough competition from its neighbours. As a result, Sunaqua turned to corporate identity as a critical channel to rethinking the office layout. The desire was to create a "boutique" where the architecture speaks about the product, which thus takes centre stage in a space that is barely reminiscent of a traditional, static showroom. Instead of planning a combination of single function spaces, the 7,000 square foot industrial loft was designed as a series of integrated areas, with working offices segregated by up-lit grids of shelving for storage, illumination and privacy.

Every architectural element presents an opportunity to inform customers about the merchandise, manufacturing techniques and craftsmanship of the company. Customers immediately identify the company with wool products owing to a light-box wall racked with large glass test tubes filled with yarn samples. A central glass-enclosed demonstration area contains knitwear machinery. Customers look on whilst their wool samples are made up for them on the spot. It reinforces the perception of a company that is efficient and service-oriented. Large framed photographs, shot from the factory floors and workshops, tell the company story in terms of production and context.

The product needs to be communicated to customers in various ways – from its raw material state to sample swatches and finished garments. This challenged the designer to consider a number of innovative display systems and lighting techniques in order to represent the product to maximum effect. Dowelling rods are attached to a sliding track overhead and entwined with skeins of wool and cones of spun yarn. Besides showcasing the product, they act as an adjustable screening device and also define circulation. With severe limitations in terms of budget, materials and locally available construction expertise, Sunaqua Concepts have used dexterity and sensitivity to prove that creativity is by no means a question of abundant resources.

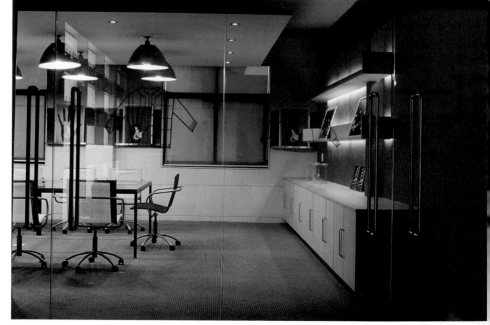

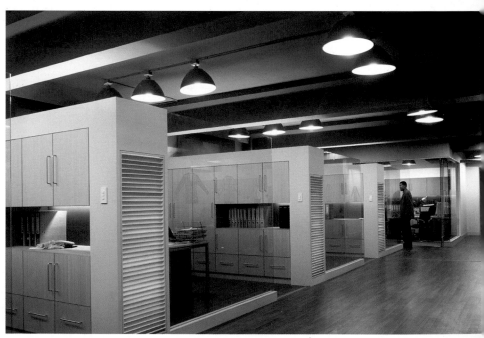

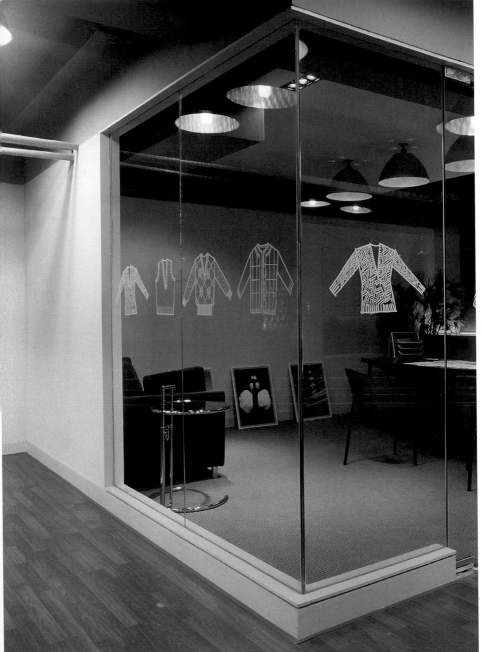

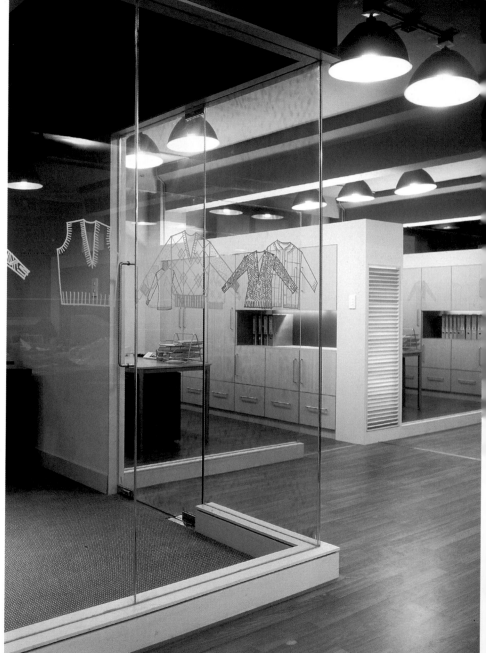

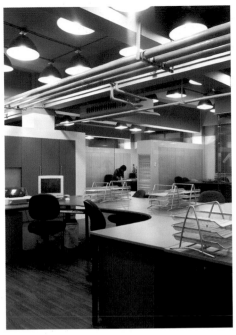

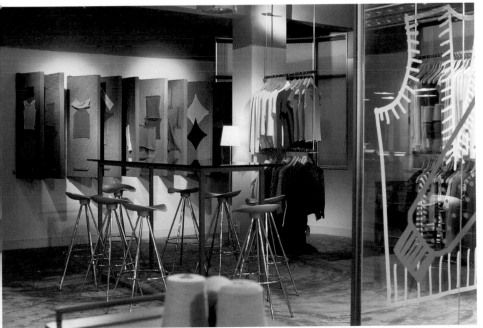

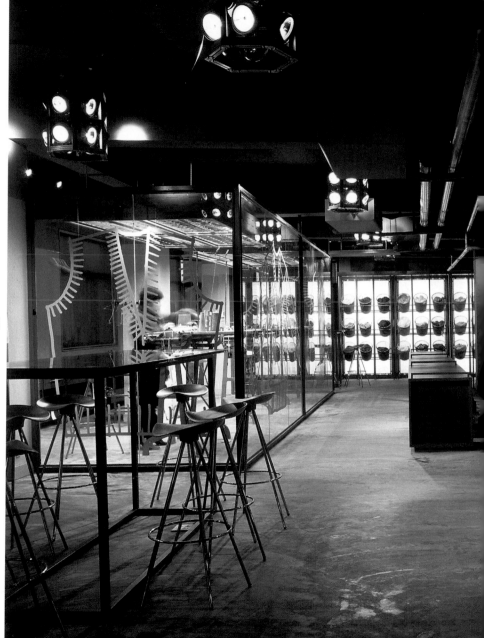

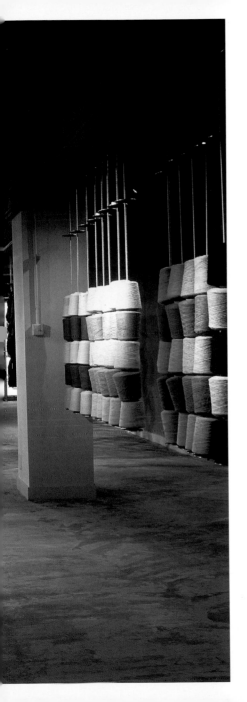

AN ATYPICAL INSTALLATION

lgt bank

The LGT Bank of Liechtenstein bears no resemblance to the banking world that most investing customers are familiar with. The interiors are surprisingly un-corporate, quintessentially tasteful and boutique in scale, rather than pretentiously grand; so much so that it's almost a lesson in rigorous domesticity.

NAME OF OFFICE **LGT BANK**
OWNER/CLIENT **LGT BANK IN LIECHTENSTEIN**
ARCHITECT/DESIGNER **L & O ARCHITECTS**
PHOTOGRAPHER **COLIN HAMILTON**
TEXT **ANNA KOOR**
LOCATION **CENTRAL, HONG KONG**

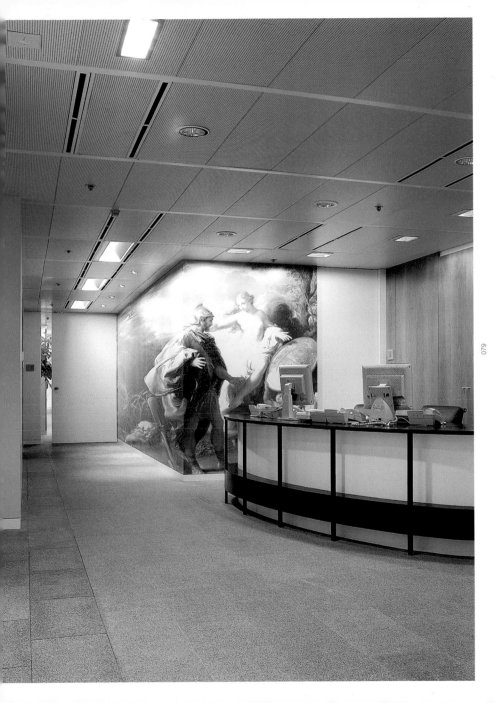

The designers at L & O Architects have invented much to excite the staff and the select elite who are invited through the fortress-like walls of the LGT Bank. Indeed, alighting from the lift there is no indication of an opening, only a daub of orange that backdrops a sandblasted glass panel over which the company insignia is etched out. One obviously needs to be primed. Like motioning a computer mouse around a website home page until something clicks, the uninitiated must side-step around the lift lobby touching walls and pressing panels until, quite unexpectedly, a solid piece of granite wall slides back.

The orange reveals itself to be a blown-up reproduction of a famous Batoni painting, which stretches around the corner to the elliptical reception desk – a post-modern construction that avoids the cliched, typical monolithic block that the designer describes as an "army installation". The stretched painting images – the other being in the conference room – are "borrowed" from two Batoni originals that are kept in Liechtenstein and form part of the Bank's art collection. Using these mural-like images as wall finishes was a deliberate alternative to the predictable application of marble, and their presence makes a link back to the geographical home of the company.

A concealed door behind the greeting counter hides the general office space, which lies in a bright, airy and linear space. However, the real talking point revolves around a central lounge, which is reserved for private clients. A series of meeting rooms and a conference space-cum-boardroom, radiate around this gathering point. These are not simple enclosed cubicles lined up in a row. They are generated from the curved peripheral walls of the lounge and the complex articulation of the outer elevation. Where the solid, sound-proofed side walls meet the building shell, they become transparent glass, allowing shielded glimpses to neighbouring rooms. Typical corporate interiors tend to express a repeated theme, whether in furniture or materials, but LGT Bank is defined by a deliberate mix that looks accidental rather than contrived.

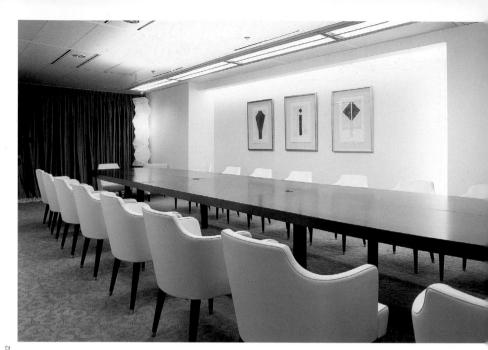

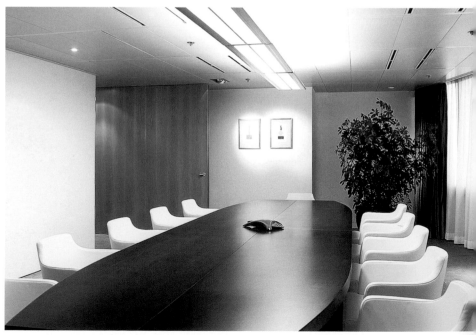

WORK AND PLAY

media nation

The Shanghai premises of this marketing company take heed of current trends in workplace design whereby the office is regarded as a place for relaxation and corporate entertainment, as well as the hard graft.

NAME OF OFFICE **MEDIA NATION INC**
OWNER/CLIENT **MEDIA NATION INC**
ARCHITECT/DESIGNER **CL3 ARCHITECTS LTD**
PHOTOGRAPHER **JOHN BUTLIN**
TEXT **ANNA KOOR**
LOCATION **SHANGHAI, PEOPLES REPUBLIC OF CHINA**

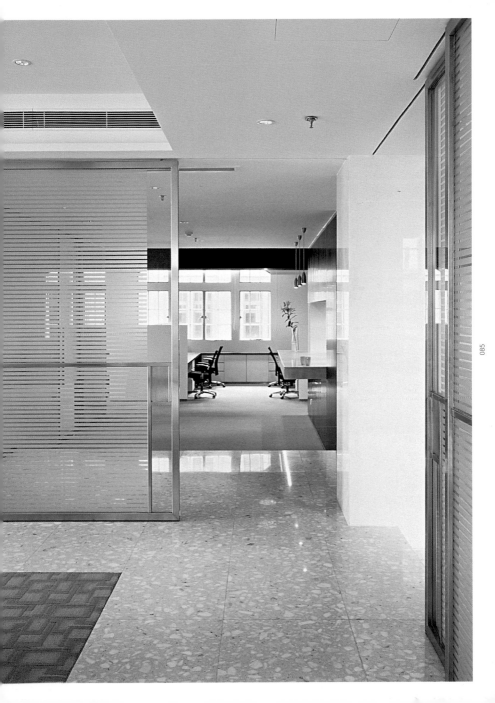

This office space is a secondary home for the client; they needed a high-end executive environment that could also be used for both formal meetings and client functions. Situated in one of The Bund's many historic buildings, it exudes plenty of heritage and charm. However, the designers were asked to retain this against a very contemporary decor that expresses a residential character.

Central to the design is a formal lounge that overlooks the city. This feeds off to a series of connected spaces that can be closed off from each other to provide enclosed areas for private meetings. Feng shui principles determined everything in the office, from the position of doors to the placement of furniture. A casual lounge on a raised platform with low dividing walls is wrapped in one corner by banquette seating to form a library space. The relaxed reading environment is delineated by an illuminated box in the ceiling, helping to define it within the overall space.

Interaction is encouraged through strong visual connections between rooms. Two rear walls of the casual lounge feature long, rectangular openings that offer a glimpse of the offices beyond. Like the public areas, these are mostly open in plan, with transparent polycarbonate panels in stainless steel frames helping to maintain visual links and enhance light transmission. Pale terrazzo is used on the floors and vertically on the low walls. This contrasts with the mahogany shelving and ebony wood veneer.

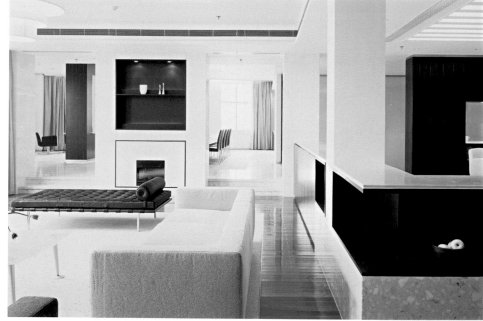

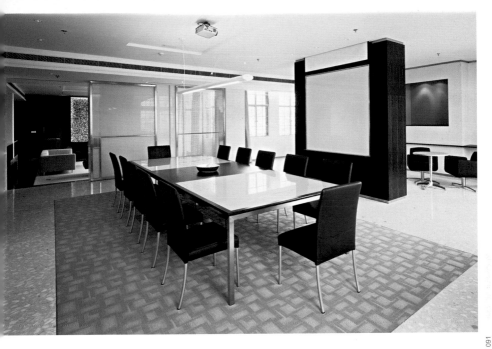

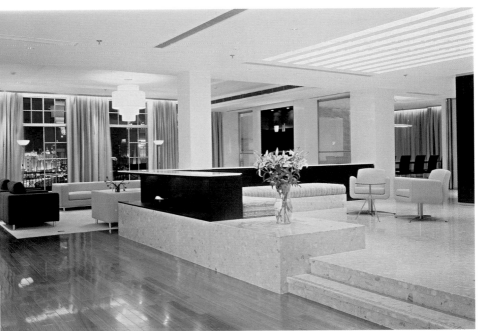

MONTAGE, MOVEMENT AND MATERIALITY

mega iadvantage data centre

Located in an old industrial area of Chaiwan on the Eastern tip of Hong Kong Island, Mega iAdvantage is said to be Asia's first dedicated high-rise data centre and the largest in the world. A fast-track design and construction programmme presented the architects with some significant challenges, which informed an "organic" design approach.

NAME OF OFFICE **MEGA IADVANTAGE DATA CENTRE**
OWNER/CLIENT **IADVANTAGE LTD**
DESIGNER **EDGE (HK) LTD**
PHOTOGRAPHY **ALMOND CHU/FRANCO K T CHEUNG**
TEXT **ANNA KOOR**
LOCATION **CHAIWAN, HONG KONG**

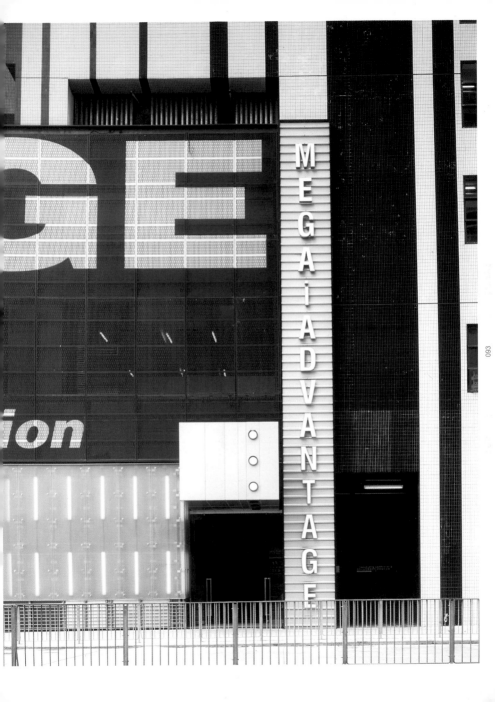

Comprising 350,000 square feet, the 31-storey structure sits on foundations that were originally intended for a different building. A 380 day inception-to-completion programme gives some indication of the difficult task that faced the architects. They describe their approach as "organic", in so far as the programme evolved during the course of construction. Given the limited time available and the absence of a static brief, the project was broken down into a series of potential schemes, starting with massing and facade studies, the design for the main lobby and a typical floor, followed by the iAdvantage headquarters and Network Operations Centre on the top two floors.

Surface is the primary element that visually defines material presence, explain the architects. However, the space is not simply a collage of finishes, or a tool for giving each material a certain status. Surfaces are broken into zones, loops and lines, even swallowing freestanding elements, such as furniture, which is designed to grow out of the floor. This is evident in the main lobby with the waiting bench, which forms part of a timber-lined security gateway. This, the aluminium-clad surveillance screen, and other linear zones – entrance, gallery, lift lobby, building management control centre – are applied in progressive sections. Therefore vertical slices through chunks of the building correspond with an orderly layering of functions, or a "montage of various spatialities".

The headquarters office on the uppermost floors of the building is conceived as a matrix of fins and surfaces with different degrees of transparency. All the surfaces become abstract from a distance, their materiality emerging only at close proximity. As an expression of speed, everything runs in a linear direction, formed by bands of different materials. Staff are allocated to "houses", in an organisational system similar to that used by schools. A double height void is the central body where team players bounce off each other via ramp, bridge or stair. This so-called "jogging track" is outlined by lighting, like a highway, and is buffered by lounging spaces around the gallery where staff can tune into movies being projected onto the floor below.

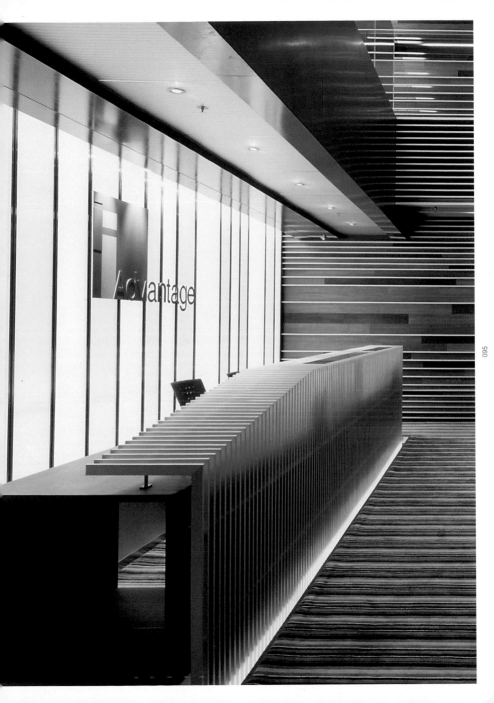

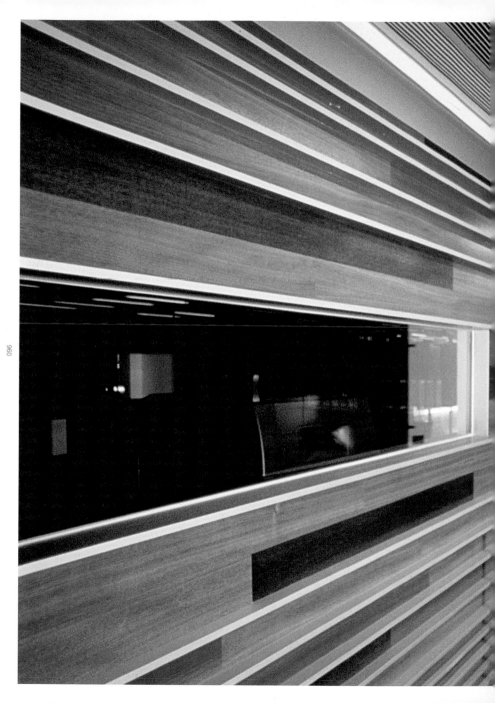

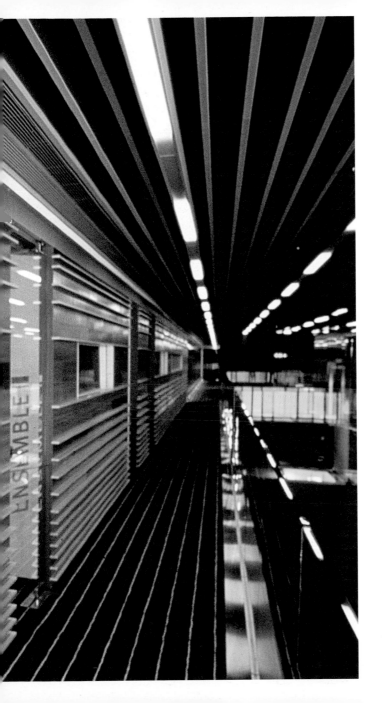

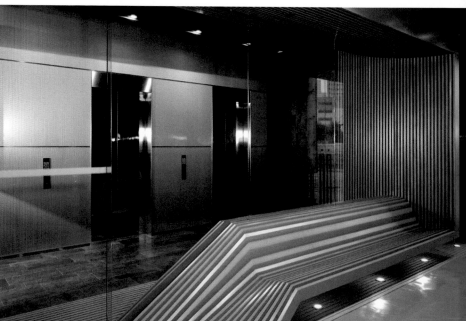

OFFICE WITH AN EDGE

nike
international ltd

This Nike office occupies several floors of a tower in Canton Road. Having designed the main office a few years previously, CL3 Architects were asked to specifically re-examine and update the design department and meeting quarters.

NAME OF OFFICE **NIKE INTERNATIONAL LTD**
OWNER/CLIENT **NIKE INTERNATIONAL LTD**
ARCHITECT/DESIGNER **CL3 ARCHITECTS LTD**
PHOTOGRAPHER **CHAN YIU HUNG**
TEXT **ANNA KOOR**
LOCATION **TSIM SHA TSUI, KOWLOON, HONG KONG**

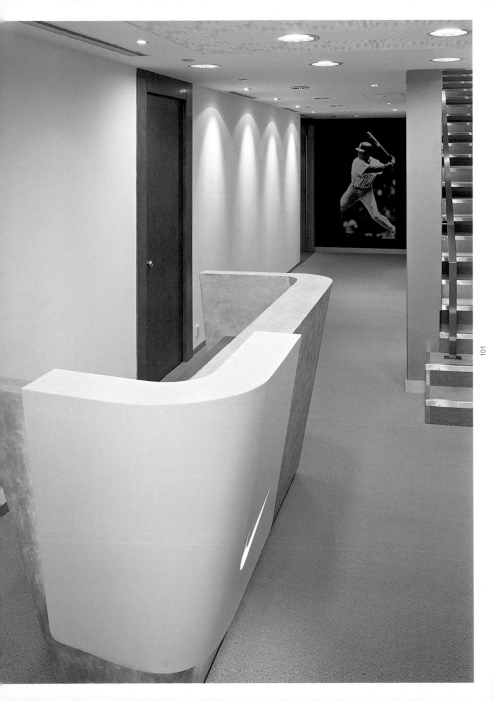

In the design department, the overall concept is intended to encourage creativity and the flow of ideas. CL3 Architects wanted to allow as much daylight to filter through the space as possible, and also to allow clear views of the harbour. A concrete floor and the noticeable lack of partitions between workstations are intended to give the space a more studio-like, casual ambience. Where divisions were required, low polycarbonate partitions have been used. Large, low tables between desks are designed to propagate ad hoc meetings. The palette is based on Nike's latest colour charts, reinforcing the sporting theme. Orchestrated applications of colour, material and detailing ensure that the environment has a well-finished edge.

The meeting area has little in the way of formal structure and is deliberately "homely", scattered with low tables and beanbags. The floor is cushioned with an inset sisal carpet. The low partitions around the meeting space double as a library wall, and materials and reference sources are easily accessible. Colour accents to columns and drop-ceiling panels were also taken from apparel colour charts.

Behind the reception desk is an amorphous form of concrete and white Corian, concealing a small changing room for models. The designers' challenge with the secondary reception on the 35th floor was to remodel the former large open space to house a flexible meeting area that could be reconfigured into as many as three individual rooms. Large colour-back glass sliding panels can be opened so that the whole office can gather in one place for functions, such as mini fashion shows and parties. Some of the walls incorporate Nike's retail panelling system, and this can be used to showcase new designs. Flexibility also had to be designed into the multi-media system and the lighting. With Herman Miller's Aeron chairs used throughout the remaining Nike offices, matching Caper chairs were selected for the meeting rooms. The chairs are light and stackable for easy storage, as are the maple topped meeting tables.

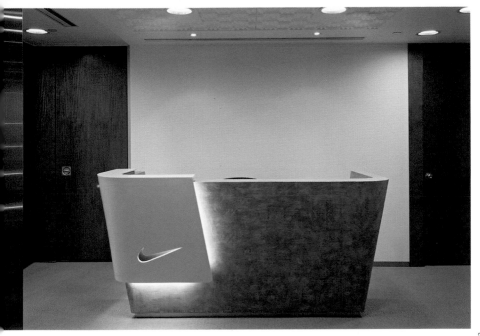

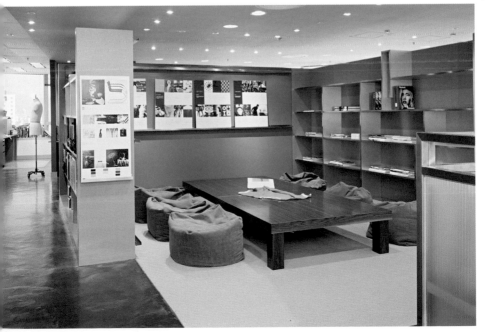

INNOVATIVE SOLUTIONS

ove arup & partners hong kong ltd

Ove Arup is an international multi-disciplined engineering consultancy with a worldwide reputation for innovative solutions. In order to reflect their working philosophy and progressive culture, their office space had to showcase the company image.

NAME OF OFFICE **OVE ARUP & PARTNERS HONG KONG LTD**
OWNER/CLIENT **OVE ARUP & PARTNERS HONG KONG LTD**
ARCHITECT/DESIGNER **CL3 ARCHITECTS LTD**
PHOTOGRAPHER **STUART WOODS - SW PHOTOGRAPHY**
TEXT **ANNA KOOR**
LOCATION **YAU YAT CHUEN, KOWLOON TONG, HONG KONG**

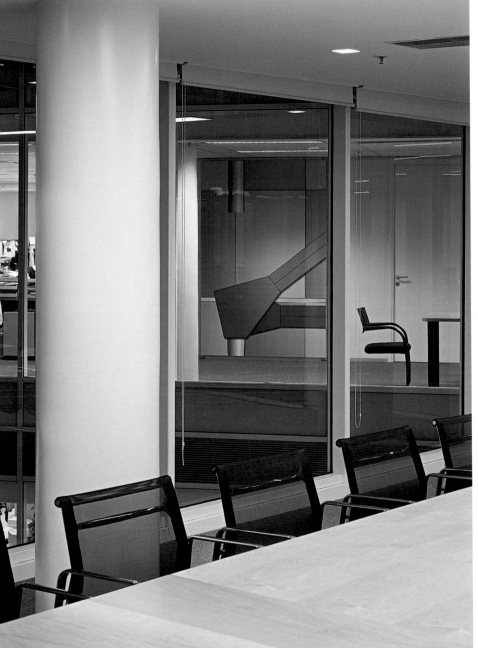

The designers at CL3 Architects used the concept of a "village" network as a framework to identify department teams, whilst enhancing the feeling of the overall Arup community. Glass pivoting doors open into a generous reception area, where the shadow from the etched Arup logo is cast on the floor by targeted lighting. Contrasting floor finishes – from white marble to dark timber and grey carpet – are continuations of axis lines taken from the architectural shell, and create a dynamic patchwork of textures. Appropriately, the reception desk possesses an "engineered" form of cantilevered marble on a walnut base. The clusters of lounge chairs are a breathing space outside the heart of the working environment, and provide the opportunity for casual chats or informal meetings. The adjoining boardroom has a back-painted operable wall, allowing meetings of various sizes.

An internal escalator from the reception emerges next to the cafe and open pantry on the upper level, which extends outside to the sun-filled atrium. This area is designed as a casual and relaxing break-out zone, to encourage interaction between staff across the various engineering disciplines. The floating Corian bar is powered up for laptop usage. Associations with memorable Arup projects are graphically represented in different scales around the office and even served as references when detailing components of this scheme – such as the footplate of the bar.

Colour-coding is used to help distinguish the six key disciplines, without rigidly conforming to physical boundaries. Sandwiches of grey flooring act as neutral zones in between the discipline areas. It was essential to avoid the syndrome of an anonymous field of desks. Large areas of desks are broken up with meeting points with project pin-up boards.

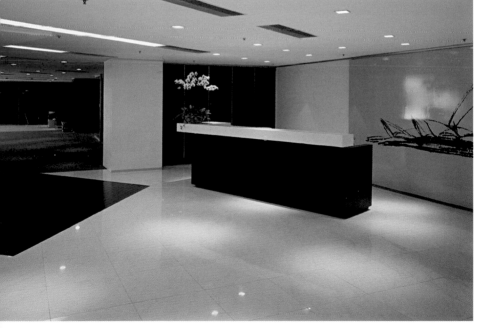

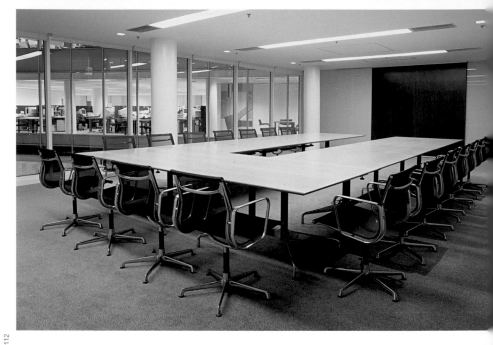

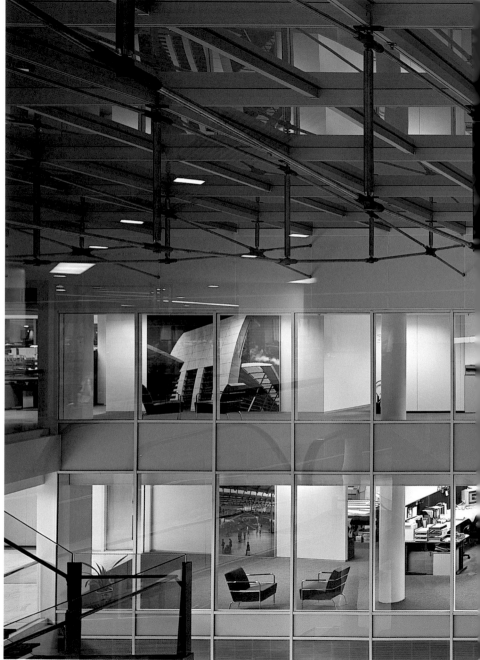

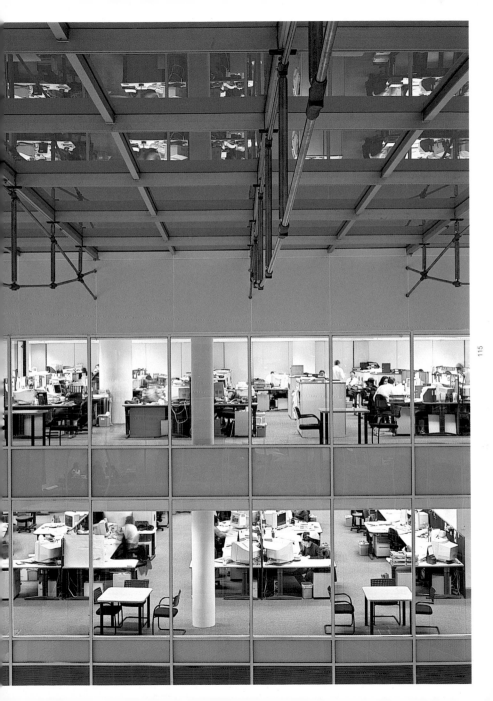

THE RIGHT SIGNAL

rthk medialab

The studios of RTHK took a leap into the future with the opening of the Medialab. Architect James Law considered it a hybrid artificial intelligence space that enables RTHK to experiment with new broadcasting methods such as web-casts and digital recording.

NAME OF OFFICE **RTHK MEDIALAB**
OWNER/CLIENT **RADIO TELEVISION HONG KONG**
ARCHITECT/DESIGNER **JAMES LAW CYBERTECTURE INTERNATIONAL**
PHOTOGRAPHER **ANDREW CHESTER ONG**
TEXT **ANNA KOOR**
LOCATION **KOWLOON TONG, HONG KONG**

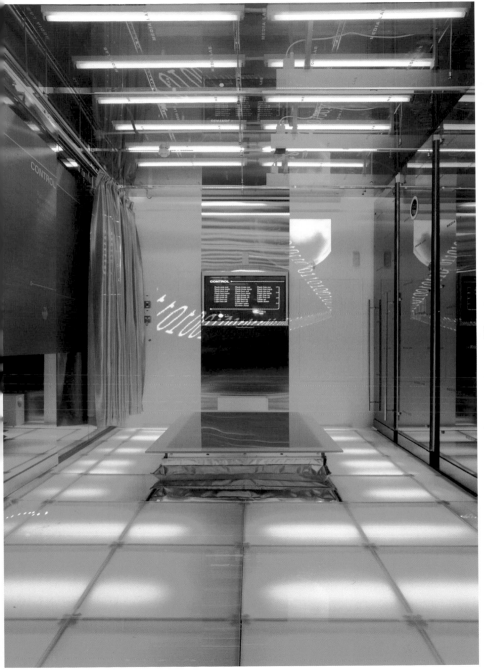

James Law's "Cybertecture" is, he explains, a form of design that uses technology to embody both physical and virtual architecture in a symbiotic balance for the future world. For the RTHK Medialab, he worked with system integrator PCCW and wireless technology experts Cybernation to create a seamless experience for the user. The Medialab consists of a 7.5 x 4.5 metre box, which has been inserted into the existing RTHK studios. It fulfils various functions, operating as an electronic workshop, a training facility, and a showroom or stage set. As such, it contains a large amount of technological equipment, bringing together all the tools necessary for any type of broadcasting.

Medialab's usage is closely supervised by a digital entity called "Signal". Its physical presence is denoted by a watchful oscillating "eye", and it engages in conversation via a sophisticated voice recognition system. "Signal" is central to the useability of the Medialab, supervising the room like a professional personal assistant. When the Medialab is not in use, "Signal" refuses to sleep; instead it performs visual gestures, making comments and spewing trivia information, even adding seasonal greetings, which are prompted by an in-built calendar. Through motion detectors and digital signing-in procedures, "Signal" wakes up when people walk by or enter the space through its sliding doors.

Finding the dimensions to fit all that technology was a huge challenge, which was resolved by using one elevation as a floor-to-ceiling digital filing cabinet. Tell "Signal" which tool is needed and out it pops from a disguised wall that contains a bank of seven equipment racks. When the designated session is finished, the technology retracts back into the wall. Thus "Signal" enables the entire room to reinvent itself for a specific function, allowing optimum space and flexibility. The enclosure to the cube also has a life of its own. Wrapped in specialist glass, when occupied it is semi-transparent from the outside for privacy and mirrored from the inside to give the illusion of a larger space. When not in use, it turns into a mysterious black box.

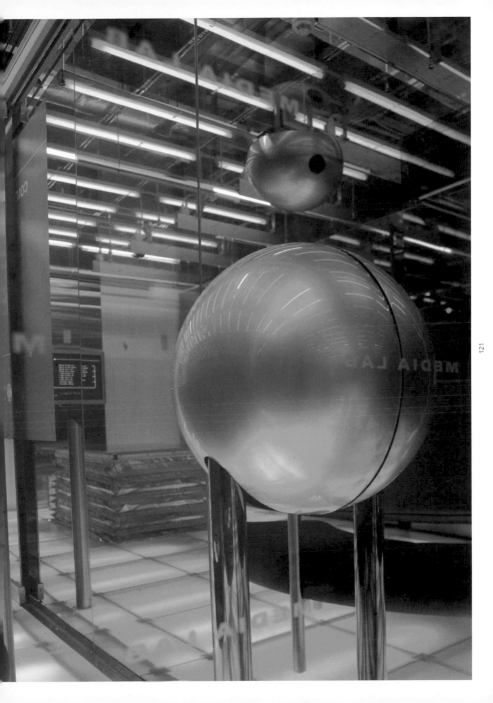

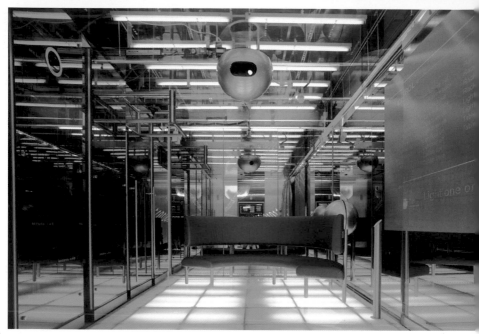

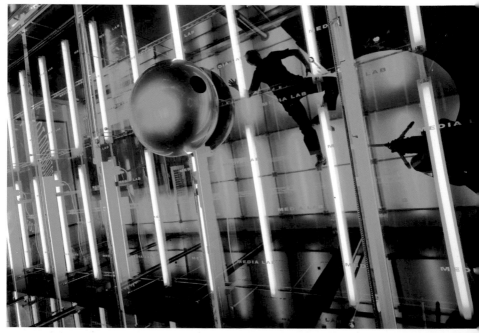

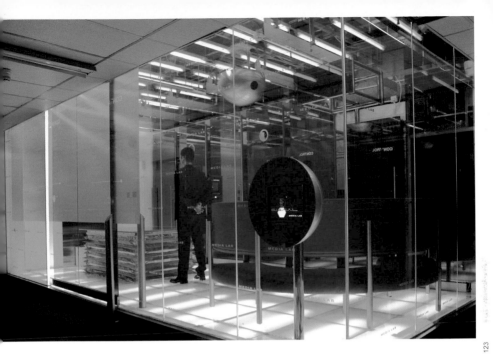

LUXURY AND LONGEVITY

sithe asia

This office is the flagship Asian headquarters of a leading American power company. Fluid spaces are married with natural stone and mineral finishes to provide clues about a business based in concepts of longevity and strength.

NAME OF OFFICE **SITHE ASIA**
OWNER/CLIENT **SITHE HONG KONG POWER SERVICES LTD**
ARCHITECT/DESIGNER **RHK**
PHOTOGRAPHER **PAUL HILTON**
TEXT **ANNA KOOR**
LOCATION **CENTRAL, HONG KONG**

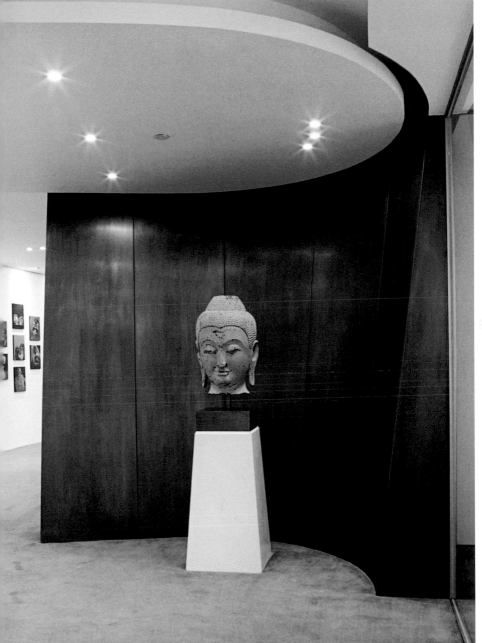

A generous 22,000 square feet of space gave the designers a dramatic expanse of light and space to work with. The base building is blessed with generous floor-to-ceiling dimensions and full-height windows. The floorplate, of a rigidly square configuration, might have been a benchmark for the interior design scheme to hang from, but the designers chose to reverse this strategy and work from the inside out. Rather than breaking up the floor space into disjointed segments, a series of interlocking geometries give an overall impression of seamlessness and fluidity. A semi-elliptical reception desk of solid marble creates a firm anchor within a continuous flowing reception and lounge area, which is paved in slate. The curves are not only a welcoming gesture but establish a dynamic through the space, drawing the eye to the expansive view from the far windows. This approach also satisfied feng shui requirements.

The client's nature of business gave some signals to the designers in terms of analogies such as strength and longevity. These attributes are quietly expressed in natural stone and mineral finishes. Bronze, stone, metals and glass are applied in confident swathes. The luxury of space is enhanced by leaving the perimeter walls free and uncluttered. Junctions where floors meet walls and where walls meet ceilings are places where RHK also focused their attention, paying due respect to the transition of spaces, and ensuring that there are no sudden stops and starts. As such, the slate floor of the reception extends outwards across the lift lobby. Details such as recessed skirtings and edges, as well as drop-ceilings, enhance the ambiguity and exaggerate forms and verticality.

For similar reasons, the adjoining meeting room and client lounge are floated off the floor. The private lounge sensitively protects the identity of visitors from others who might be lingering in the reception area. The intense blue carpet inset is a reminder of the corporate logo colour. Further on, the conference room is signified by a curving bronze wall and can be divided in two. The steel framed glass wall draws attention to the display of mask paintings on the wall.

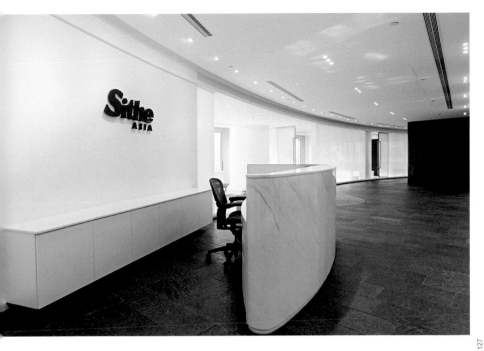

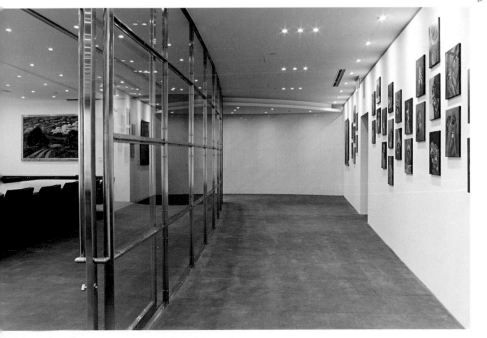

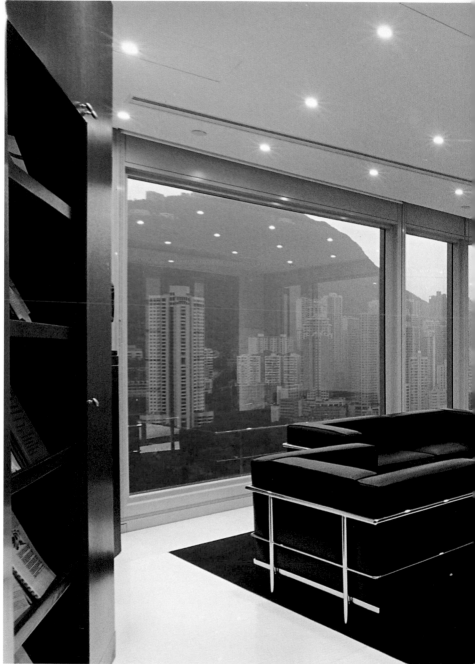

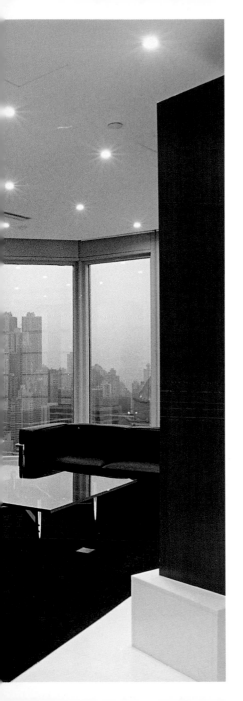

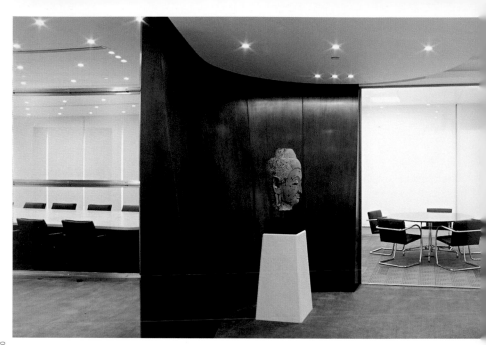

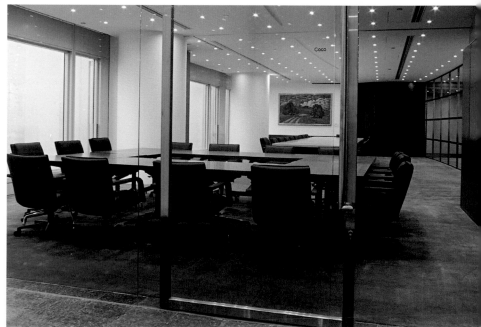

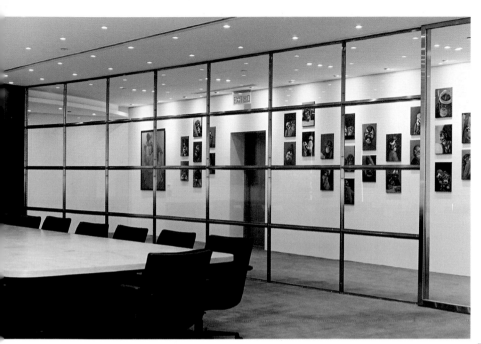

DYNAMIC DESIGN HUB

underline:fitch

Within the confines of a limited budget, Atelier Pacific have provided this dynamic graphic design and branding company with a simple and bright container, in keeping with the company's identity, and providing the design teams with a studio hub to foster creativity and interaction.

NAME OF OFFICE **UNDERLINE:FITCH**
OWNER/CLIENT **UNDERLINE:FITCH (FORMERLY BGX)**
ARCHITECT/DESIGNER **ATELIER PACIFIC LTD**
PHOTOGRAPHER **WILLIAM FURNISS/FUTURE POSITIVE**
TEXT **ANNA KOOR**
LOCATION **CAUSEWAY BAY, HONG KONG**

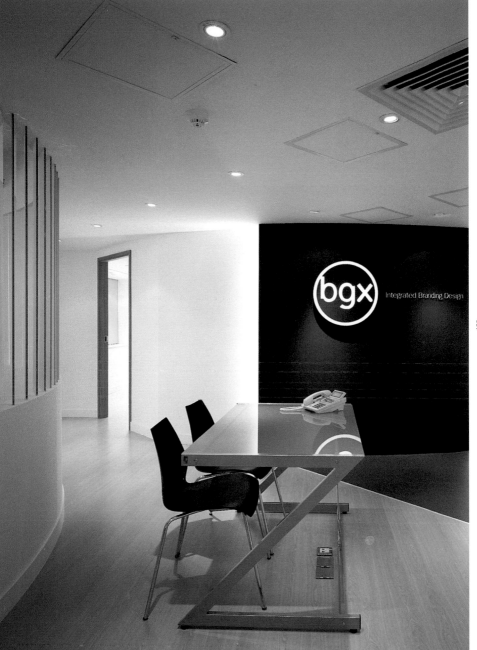

The Underline: Fitch identity is a major theme in their new office environment. The company's image is stamped firmly from the outset by a "graphic" wall of horizontal glass fins in the lift lobby. The designers wanted to represent the company's identity without being too blatant, or too abstract. The fins – 10 millimetre thick glass protrusions in primary colours – are staggered across the wall in varying depths, creating a 3-dimensional wall sculpture. This is heightened by targeted lighting, which creates shadows of colour on the wall, giving it volumetric depth.

Within a limited budget, the designers created a simple and bright container, minimising walls. Where walls do occur, they are formed with transparent materials to maintain the sense of openness. In the reception area, a wall of vertical frosted glass fins are arranged in a curve, separating the public space from the working office. It provides enough transparency to give visitors a glimpse of Underline: Fitch at work, whilst ensuring that the account managers are not compromised by lack of privacy. Where there are solid walls to enclose offices, the upper portion above eye-level is constructed of coloured expanded polycarbonate panels or clear glass.

The studio required an open plan layout, but also some separation for the account managers/administration team, to allow privacy and a quieter environment when dealing with clients. An elongated octagonal floor plate was instrumental to producing a series of clustered environments denoting the various divisions of the team. Within the creative zone, the plan is configured in mini-pods, which accommodate three users at a time. Sliding presentation panels conceal shelving units within the design studio. Flat files are used as the production layout table base, providing the required storage whilst maintaining a clean, organised space. The inclusion of a large pantry and breakout area in the space, with "playful" designer furniture, creates a colourful and relaxed environment, which reflects the company's image.

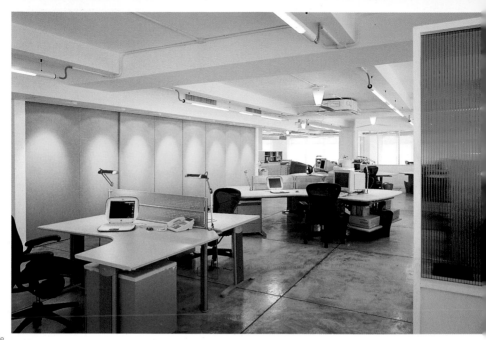

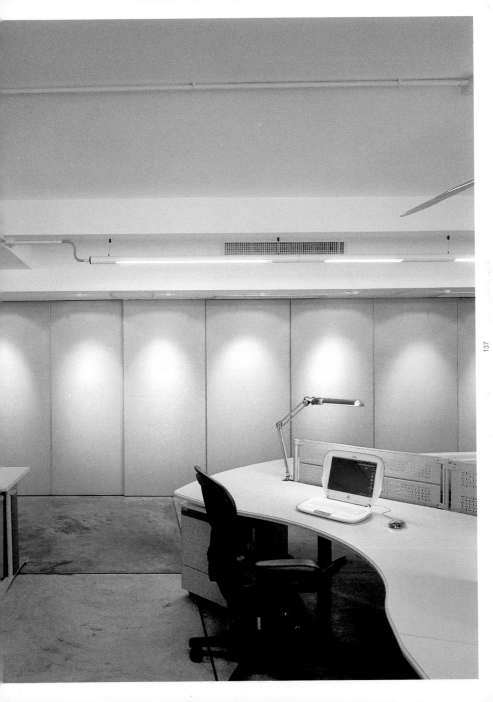

ELECTRICAL CONDUCTIVITY

sony ericsson indonesia headquarters

With the merger of two electronic giants from Japan – Sony with Ericsson Swedia – arose the need for a new Indonesia headquarters. Glass is used as a main material to achieve a clean, modern design.

NAME OF OFFICE **SONY ERICSSON INDONESIA HEADQUARTERS**
OWNER/CLIENT **SONY ERICSSON**
ARCHITECT/DESIGNER **GREGORIUS YOLODI SUPIE; STYLING BY IMELDA AKMAL**
PHOTOGRAPHER **SONNY SANDJAYA**
TEXT **IMELDA AKMAL**
LOCATION **JAKARTA, INDONESIA**

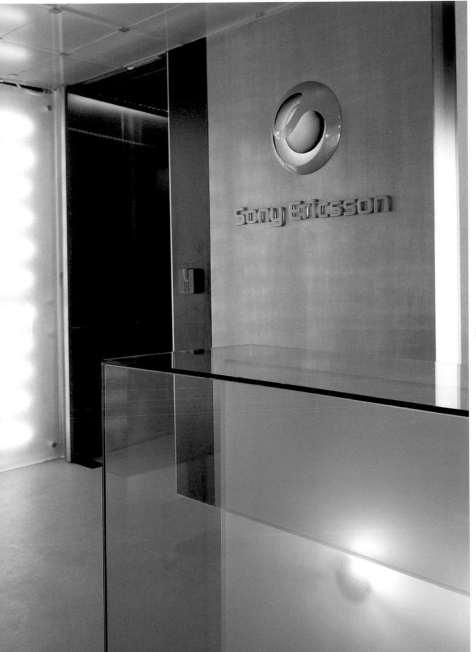

The new headquarters are required to fulfill two functions: firstly, the accommodation of all staff, and secondly the ability to showcase the latest technology that the company has achieved. The design brief asked for a form that would visually reflect the technological sophistication of the cellular phone: being both modern and advanced. But it was also required to reflect the fusion of two cultures: Asian and European. Most of all, the office should project a brand new image.

The office layout is divided into two zones. The public and showroom zone is situated in the front part of office. Behind this area is the office zone containing workplaces for all the staff. To project the image of modern, sophisticated technology, a clean and modern design scheme was chosen as a starting point. Glass is used as a main material – not only for windows and doors, but also as walls and ceiling. Four pillars, fluorescent-lit, are used as a base on which to show the latest products. The most interesting part is probably the ceiling, which is made of square panes of frosted glass, hung with alumunium rods. The greenish light that is cast from the sandblasted glass is a metaphor for the green colour of the new logo for Sony Ericsson.

The office area shows the mixture of Japanese and Swedish cultures. There is one same element of architectural design in both cultures: the use of slatted timber. This element is mainly used in the connecting alley between the showroom and the office. The use of timber in the office area gives this workplace a cosy and friendly feel. Glass and metal finishes are also used in the office area to suggest a hi-tech atmosphere.

A NEW APPROACH

beacon communications office

Klein Dytham architecture (KDa) has almost reached a pop-star status in the architecture scene of Tokyo. Their scheme for the office of new advertising agency, Beacon Communications, does not sway from the humorous style that they have become famous for.

NAME OF OFFICE **BEACON COMMUNICATIONS OFFICE**
OWNER/CLIENT **BEACON COMMUNICATIONS K. K.**
ARCHITECT/DESIGNER **KLEIN DYTHAM ARCHITECTURE (KDA)**
PHOTOGRAPHER **KOZO TAKAYAMA**
TEXT **KWAH MENG CHING**
LOCATION **TOKYO, JAPAN**

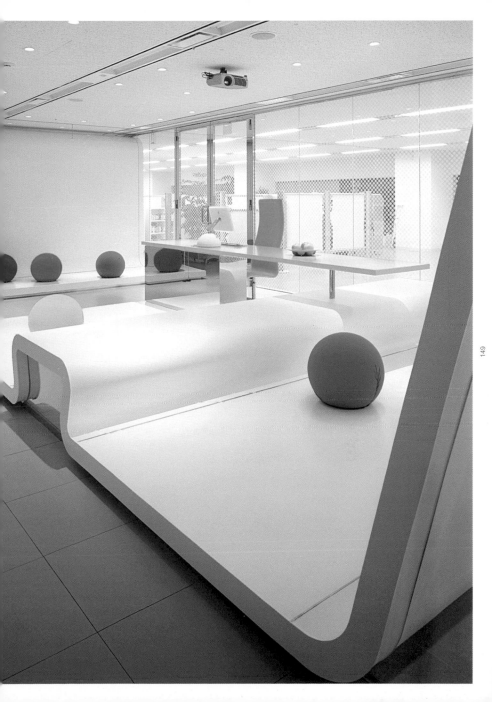

KDa's bold, distinctive and playful approach to design, be it architecture, interior, product or even construction hoardings, easily distinguishes it from those who belong to the minimalist school. Their design for the office of Beacon Communications bids farewell to the conventional office, transcending the notion of a "workspace". KDa's design not only creates a dynamic stage set for creative activity; it also forms an attraction in itself, and serves as good advertising for the agency, by providing entertainment for visitors and arousing the interest of potential clients.

Occupying levels 11 to 14 of a 17-storey office building in Tokyo, the 60 x 15 metre column-free spaces command some stunning views. Instead of the usual open-plan office cubical layout – whereby the management is housed in a private enclosed space fronting the view – KDa have created a unique office whereby the view is shared by everyone. The dominant feature of this office interior is a giant ribbon that extends the full length of the 60 metre space throughout the four floors. Flowing continuously, this articulated ribbon creates different kinds of shared spaces, with its planes acting as ceiling in some areas, and as walls and seats areas at others. Larger multi-purpose space and seating galleries, smaller meeting areas and even semi-private alcoves for a little nap are accommodated above, beneath and within the ribbon. Glazing the spaces created the necessary privacy, whereas leaving it open allows the space to spill into the main office. While everyone has their own private workstation, they are just a step away from the ribbon whereby private conversation and meetings can be held.

The appearance and programme of the ribbon further takes on different forms at different floors, to echo Beacon's division of the agency according to themes: "Woman", "Man", "Family" and "Community". Forming part of the ribbon on the "Woman" floor is a hair salon and beauty centre, with the ribbon exhibiting a pink snake-skin pattern. The "Family" floor ribbon, finished in maple wood, revolves around a functional kitchen with cooking and laundry facilities. A steel-finished ribbon in turn marks the masculinity of the "Man" floor.

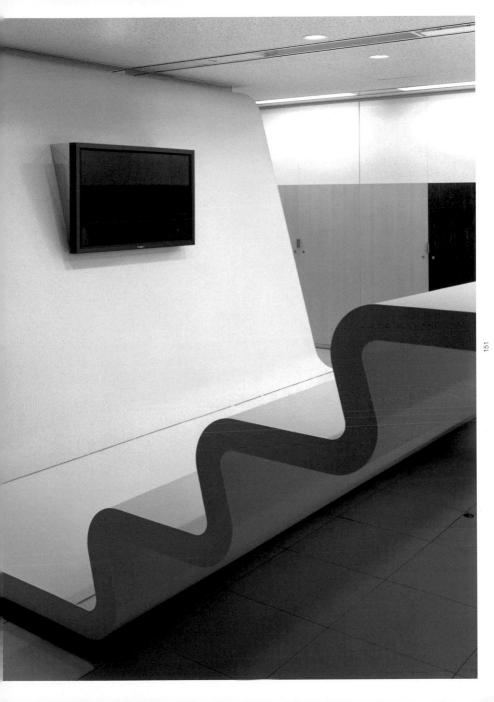

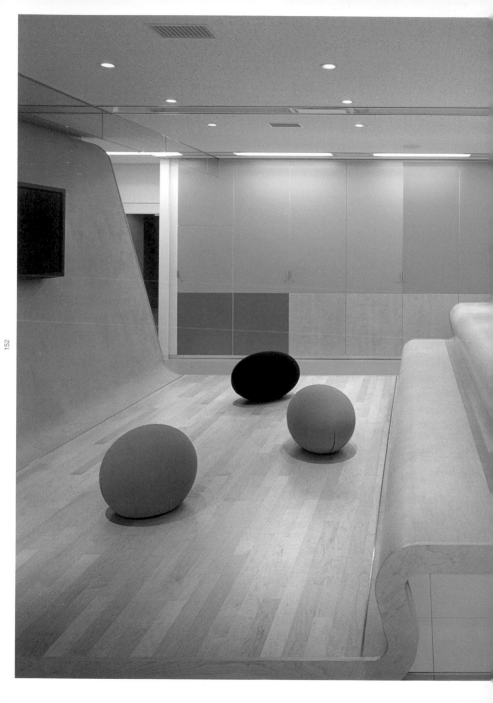

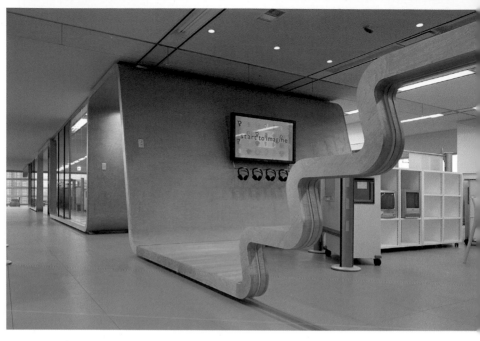

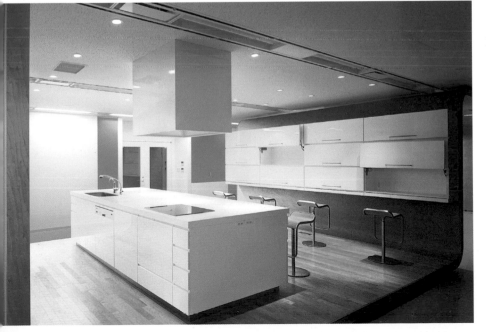

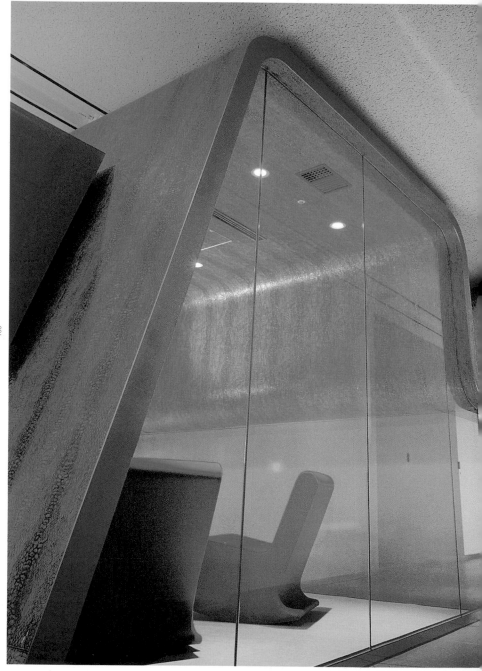

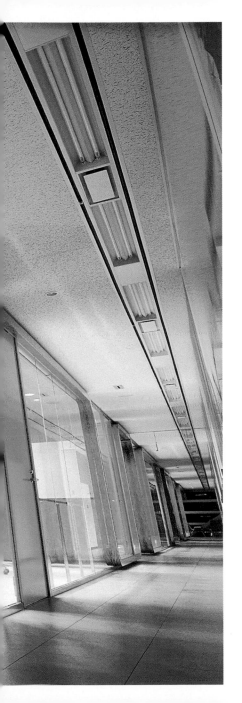

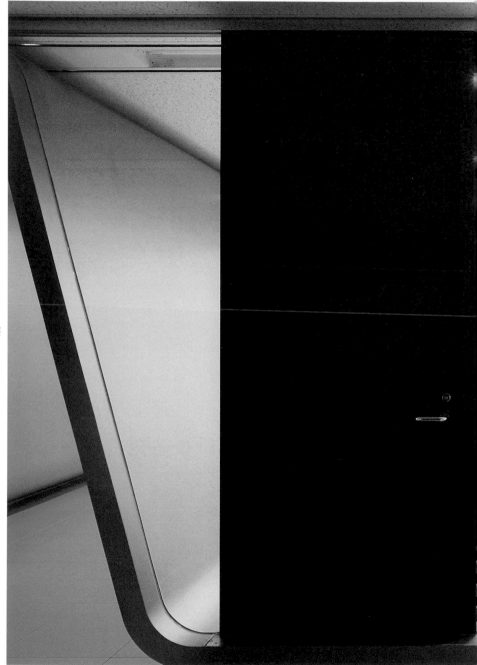

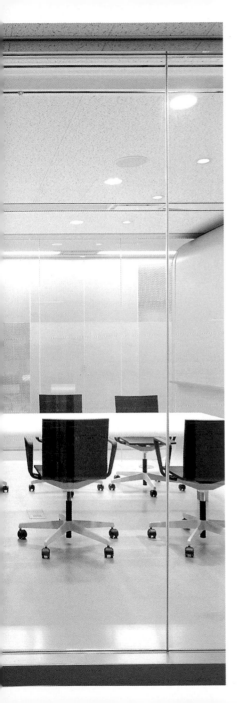

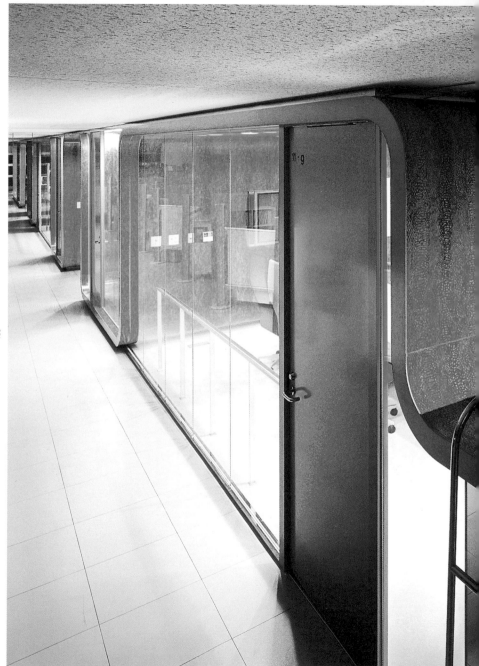

UNCONVENTIONAL OFFICE DESIGN

ippee inc

ippee is an Internet information company dealing with the planning and administration of musical websites. Yasuo Kondo has captured the young, fresh and speedy qualities that typify the image of such business, and translated them into an unconventional office design.

NAME OF OFFICE **IPPEE INC**
OWNER/CLIENT **IPPEE INC**
ARCHITECT/DESIGNER **YASUO KONDO/YASUO KONDO DESIGN OFFICE**
PHOTOGRAPHER **NACASA & PARTNERS INC**
TEXT **KWAH MENG CHING**
LOCATION **TOKYO, JAPAN**

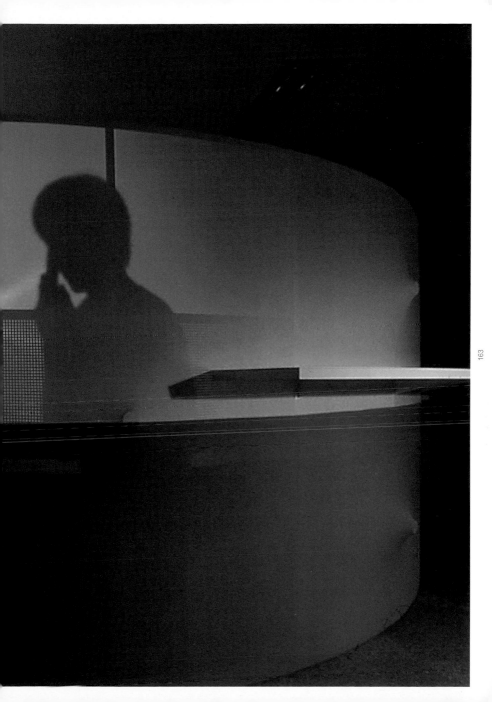

The entrance lobby to any corporation is of utmost importance. Not only does it personify the philosophy of the company, but it also has the dual task of creating a lasting impression in the visitor's mind. The entrance lobby of ippee is one that manages to perform these dual roles successfully. The punched metal-mesh wall of this lobby has had numerous CDs inserted into it, creating an interesting decorative pattern and shadow. While acting as a filter screen, this wall also serves as a natural advertisement for the company, communicating a "funky" and playful image powerfully and effectively.

The office proper contains the usual division of staff space, marketing department, system department and so on. Yet, they are not partitioned into rooms and divided with the conventional rectilinear partitions. Instead, the office has an open concept, where the departments are organised and arranged into various groups of arc segments. Each segment is comprised of the usual table-tops for workstations, as well as a "membrane" wall of punched metal and brightly-coloured fabric. This fabric is the same material that is used to manufacture swimming costumes. It is deployed here to wrap around and delineate the different territories within the office.

The "membrane" walls are further rendered with a 3-dimensional quality through the installation of steel tension rods on the inside, creating little protrusions at regular intervals. Subtle differentiation of different areas is subsequently defined by the three different heights of these "membrane" walls. Delicate to the touch, the "membrane" softens the usual hard-edged office interior, and dissolves rigid territorial concepts in the office.

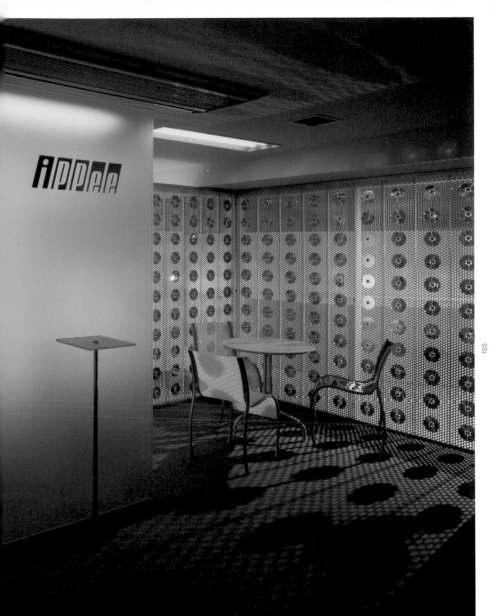

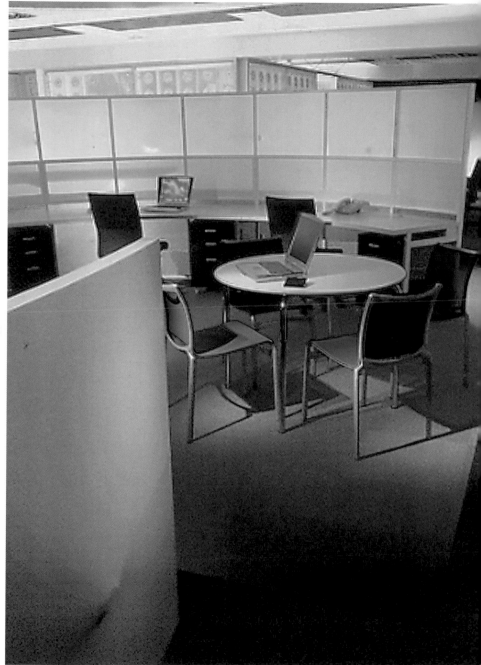

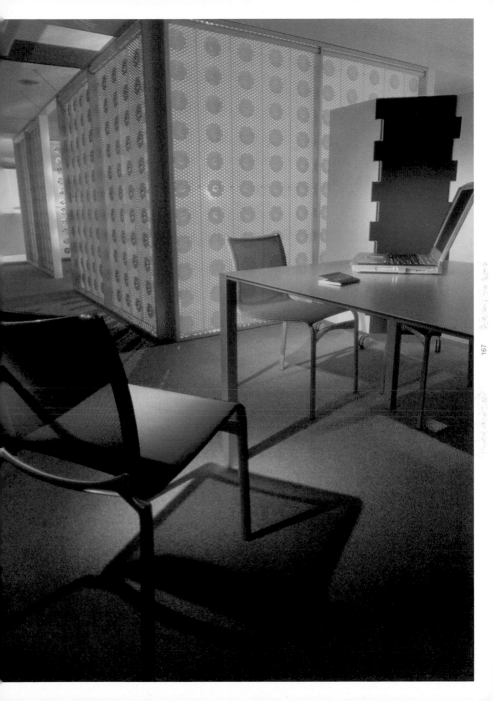

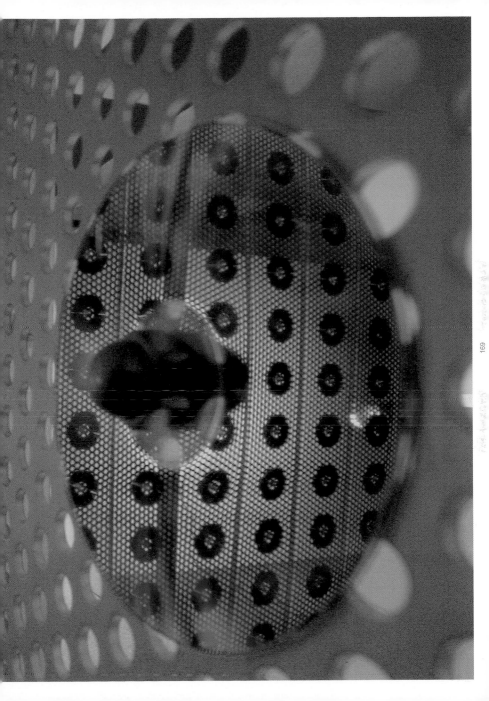

WELCOMING AMBIENCE

nansei
rakuen co

The office of real estate agents Nansei Rakuen sweeps aside the cold, utilitarian image of many estate agents, and creates a warm and welcoming ambience for the nervous home-seeker.

NAME OF OFFICE **NANSEI RAKUEN CO**
OWNER/CLIENT **UNIMAT REAL ESTATE**
ARCHITECT/DESIGNER **YASUO KONDO/YASUO KONDO DESIGN OFFICE**
PHOTOGRAPHER **NACASA & PARTNERS INC**
TEXT **KWAH MENG CHING**
LOCATION **TOKYO, JAPAN**

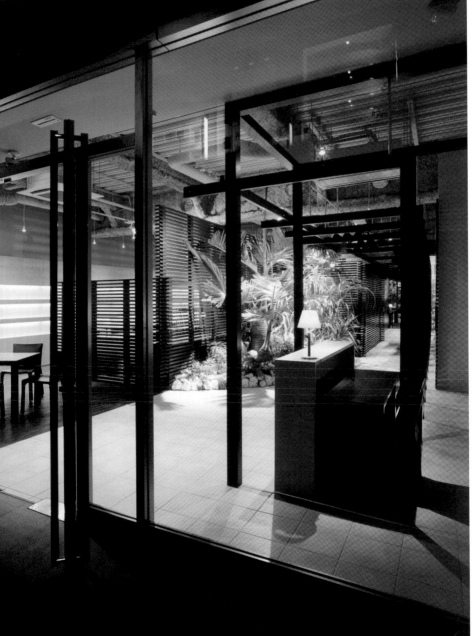

Visiting the offices of property agents in search of a rental property in a big city can be a nerve-racking experience for a "homeless" newcomer. The offices of property agents range from big corporate setups spanning two floors, often pompously designed with post-modern motifs, to humble "one-man" operations that occupy a small area equivalent to a simple 6-tatami mat room. It is apparent that, besides the level of service provided by the staff, the setting and interior of the property agent's office proves to be of utmost importance to the nervous client. A well-designed, cozy interior is able to set the nerves at ease somewhat, and instill a confidence in the client that the agent can be trusted with the important task of finding the ideal home.

Nansei Rakuen proves to be such a reassuring office. Designed by Yasuo Kondo for a real estate office dealing with properties in Okinawa and its surrounding islands, the design sweeps the usual cold, utilitarian image aside and creates a warm and welcoming ambience without compromising the functional aspects. At the entrance, the clear glass facade treatment enables potential home-seekers to see all the way to the back of the office. With a tropical island theme, the interior boasts an abundance of indoor plants, timber trellises and timber-slats. In fact, one would not associate it with a property agent office on first look had it not been for the signage at the entrance. One could have easily mistaken it as a hotel lobby or the foyer of a golf and country club.

The organisation of the timber-floored space is simple, with one side of the wall having white display shelves for the property information. Timber-slatted enclosures line the other side of the wall, serving as consultation spaces. The concept is carried right through to the placement of lamp fixtures on the table and the leather chairs around the table. The presence of plants and the shadows they cast further create a calming and relaxing atmosphere in sharp contrast to the conventional property agent's office.

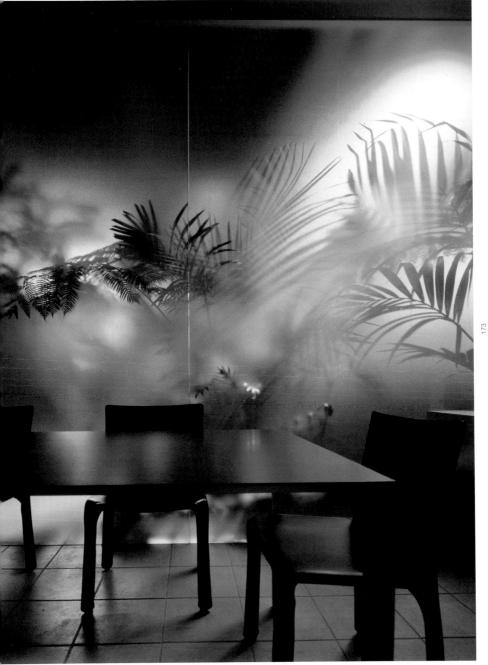

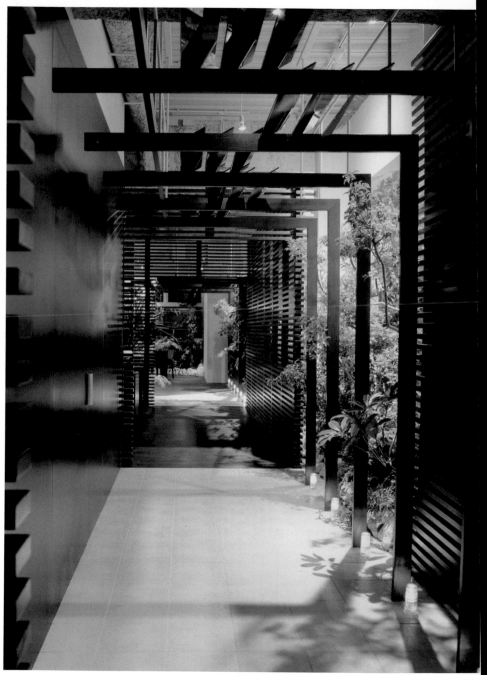

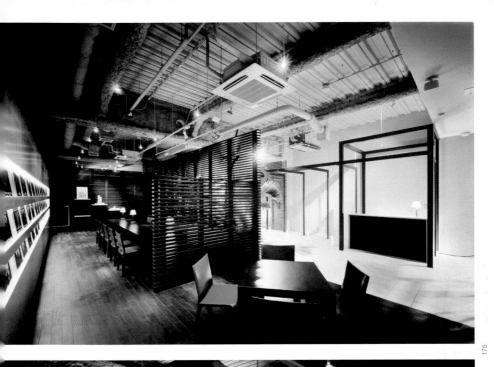

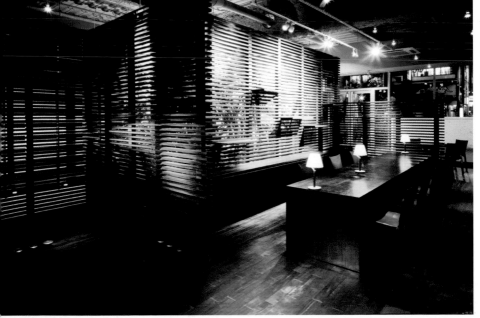

PAST AND FUTURE

ntt-x
headquarter

NTT-X is a new company focusing on the IT business, which boasts state-of-the-art technology in the IT and Internet industry. Instead of the "high-tech" office environment that such companies typically occupy, this office interior delicately contrasts new technology with an appreciation of the existing urban fabric.

NAME OF OFFICE **NTT-X HEADQUARTER**
OWNER/CLIENT **NTT-X**
ARCHITECT/DESIGNER **TOKUJIN YOSHIOKA/TOKUJIN YOSHIOKA DESIGN**
PHOTOGRAPHER **NACASA & PARTNERS INC**
TEXT **KWAH MENG CHING**
LOCATION **TOKYO, JAPAN**

NTT-X Headquarter is, perhaps surprisingly, located within an old building that was constructed in 1958. Furthermore, a futuristic palette of so-called "high-tech" materials such as glass and steel, which one might expect to see in an interior for an IT company, is noticeably absent. The designer, Tokujin Yoshioka of Tokujin Yoshioka Design, has chosen to do otherwise. A vision of the future is expressed through unexpected acrylic light tubes that run across the ceiling throughout the main spaces of the office.

Yoshioka is a designer whose work crosses different genres. Interior design is all but a small segment of his creation, which spans from spatial design of boutiques and exhibitions right down to window display, product and furniture design. His works embody an element of surprise through an innovative use of materials, which enable the design idea to be communicable on some level to adults and children alike. For NTT-X, he has adopted the concept of "optical fibre" to express the values of the company in the coming era. The lighting tubes are a derivative of optical fibre technology, thereby appropriately emphasising futuristic images for the IT and internet business.

The designer's own office was created within a 150-year-old rice warehouse structure that was dismantled and "relocated" from Shimane Prefecture to Tokyo. Similarly, for NTT-X, Yoshioka strived to breathe new life to the existing space, and maintain a delicate conversation between the old and the new. Instead of opting for a full-blown revamp, he tried to keep some of the old elements and contrast them with the new added ones. What resulted is a "lightscape", which is especially interesting when seen at night from the street. It provides a marked contrast between NTT-X office and the other offices located within the same building. Not only are the optical fibre light tubes the main feature and highlight of the office, the visual impact also leaves a lasting impression on the visitor, communicating to them the company's forward-looking perspective.

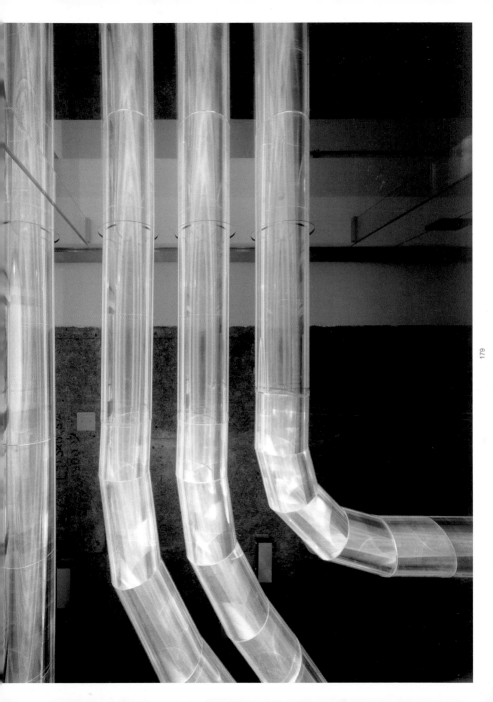

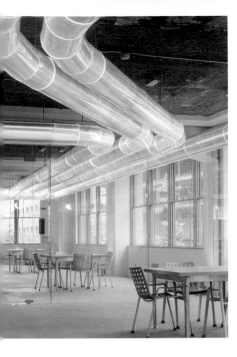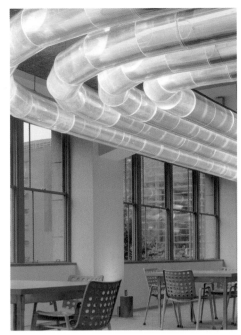

STREET SMART

office

At a time when technological advancement has dramatically altered traditional working methods, an extraordinary artificial office environment has been conceived, which brings the office to the street, and the street to the office.

NAME OF OFFICE **OFFICE**
OWNER/CLIENT **TRANSIT INC**
ARCHITECT/DESIGNER **MYEONG-HEE LEE**
PHOTOGRAPHER **SHINICHI UCHIDA**
TEXT **REIKO KASAI & MASATAKA BABA**
LOCATION **JINGUMAE SHIBUYA, TOKYO, JAPAN**

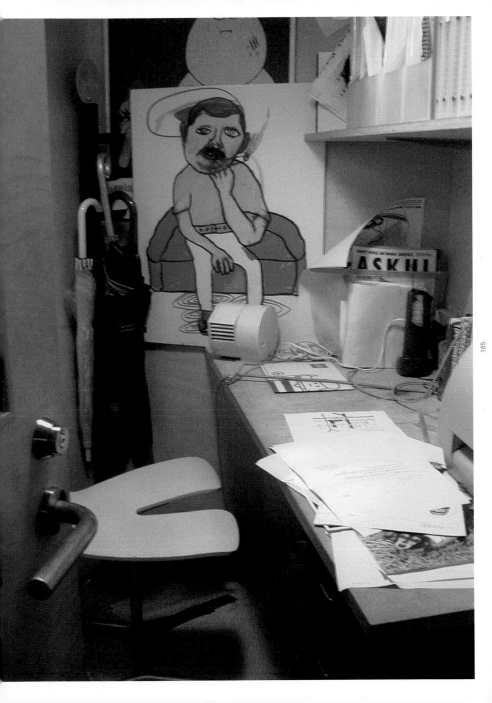

"Office" is actually the name of an artificial office environment – a cafe in fact – that contains a photocopier, a working desks and fax machines. The meaning of the "office" has changed over the years. With developments in technology, the equipment for working has been (and continues to be) reduced in scale, shrinking from an overbearing, obtrusive scale, to a bodily scale. Spatial boundaries are being eroded by instantaneous communication. Furthermore, mobile technology facilitates the worker with ultimate freedom to define appropriate working environments and conditions. As long as a mobile phone and a laptop are available to the worker, the office can be anywhere.

"Office" cafe is something extraordinary. It has become a favourite place to hold meetings, and it is not unheard of for new business networks and deals to be connected and generated there. Today, there are more and more freelancers in Tokyo. People cycle there, attend their meeting, and then leave. This speediness and roughness are just the new working styles of Tokyo, and "Office" is the place to be. It seems that the office has been released to the street; it has been integrated into the city, and the city has become a workplace itself. It is now a fact that many new ideas are generated outside of the traditional office environment.

"Office" has been designed with a definite "street aesthetic". The bright green entry door could easily be mistaken for a fire escape door. The space is roughly detailed, with exposed services, jagged-edged walls with chips unfixed, and wide timber floorboards that look like they have been lifted from an old warehouse. The service counter is a boxy timber form, deliberately designed to appear chunky and rudimentary in form. The kitchen behind has a cluttered, homely aesthetic. The shelving located in the main space holds books, magazines, brochures and toys, looking more like it belongs in someone's living room. Overlooking a busy street and clustered office blocks, one gets the feeling that the workers who breeze in and out of "Office" must feel very privileged indeed to have such freedom.

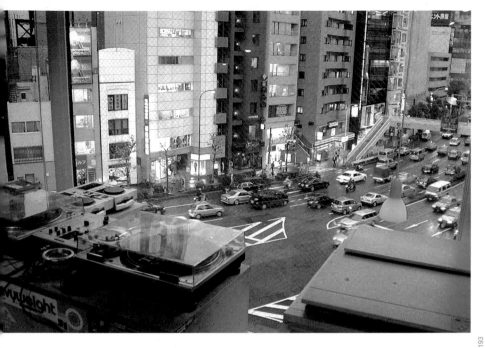

FREE AND EASY

planex
communications
inc

Created through the fusion of organic form and industrial material, the Planex Communications Inc office is a functionally and spiritually open-concept space, with a comfortable and pleasant environment that is definitely "no ordinary office".

NAME OF OFFICE **PLANEX COMMUNICATIONS INC**
OWNER/CLIENT **PLANEX COMMUNICATIONS INC**
ARCHITECT/DESIGNER **YASUO KONDO/YASUO KONDO DESIGN OFFICE**
PHOTOGRAPHER **NACASA & PARTNERS INC**
TEXT **KWAH MENG CHING**
LOCATION **TOKYO, JAPAN**

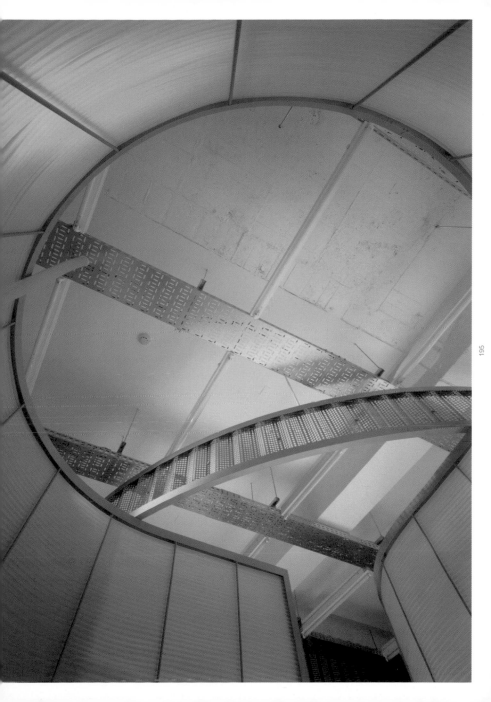

Planex Communications Inc deals with the business of the Internet, mobile computers and the development of digital communication. It occupies the 1st, 4th, 5th and 6th storeys of a building, with a total area of 10,200 square feet. The office has a motto whereby each individual member of the staff needs to fully comprehend and be confident about the company's products. In a bid to echo this individual confidence within the larger company framework, Yasuo Kondo conceptualised a design that steers away from the rigid set up and habits of a conventional office.

The entrance hall on the 1st storey reveals a blue and white staircase that leads to the upper floors, where the workspace is located. The adjacent "Information Bar" doubles as both a reception for visitors and a bar for the staff. The main feature wall of this space has been composed by recycling and arranging the base plates of the company's personal computer product in quantum, as a design detail. This attractive wall is further given a 3-dimensional quality by partly displacing the base plates at different locations and inserting light fixtures within it. When lit, the whole space transforms into a very attractive spot that is extremely suitable for a light drink or two after work.

The office space on the 4th storey boasts a huge amoeba-shaped work desk, where the seating configuration is not pre-determined. One is free to choose where one would like to sit that day. At any one time, the work desk can be transformed into a discussion table for small meetings among several members of the staff. The focus on this floor is a "Healing Space", partitioned by curved yellow polycarbonate, and complete with a lavender scent. Sitting on the bench sofa in the space, one can take a break, relax and recharge after a hard day's work. On the 5th and 6th storeys are "Free Spaces" delineated by metal-mesh curtains hung on a glide. Completely segregated from the working space, a cafe on the 6th storey completes the alternative package within the office.

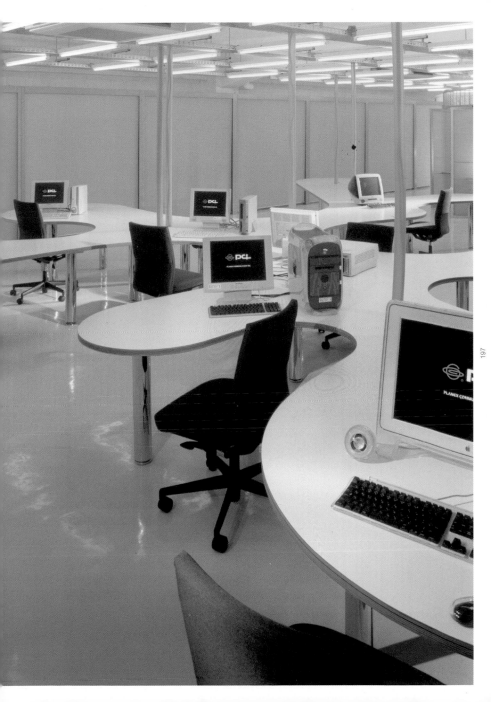

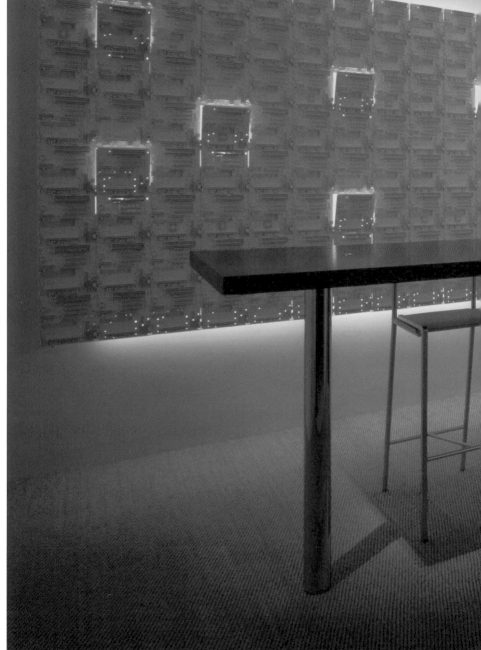

A NEW WAY OF WORKING

resonance platform

"Hot-desking" (or rather, "hot-couching") and wireless equipment lie at the basis of this revolutionary office space, which is like a platform for connecting information and accommodating communication.

NAME OF OFFICE **RESONANCE PLATFORM**
OWNER/CLIENT **RESONANCE INC**
ARCHITECT/DESIGNER **MASATAKA BABA**
PHOTOGRAPHER **DAICHI ANO**
TEXT **REIKO KASAI & MASATAKA BABA**
LOCATION **SARUGAKU SHIBUYA, TOKYO, JAPAN**

This office is for a consultancy company that deals with publication, corporate strategy and advertising. The interesting feature of the office is that there is no fixed desk for any individual worker. The staff can choose to work anywhere in the office. A wireless "Local Area Network" (LAN) makes it easy and fast to share documents with other staff. The main space of the office has a "living room" feel, with lounge seating and coffee tables, floor mats, an eclectic collection of chairs and small desks, shelving of a domestic arrangement, floor lamps and curtains. A "kitchen", backed by a collection of bottles and glasses, has a flanking bar with stools.

There are different meeting areas for different levels of meeting. An informal gathering may be held at the sofa area, while serious negotiations would be held in a confined room. For presentation and brainstorming, meetings are held in a "white room", probably the symbol of the concept of this office. The walls of the white room are actually white boards, so comments or ideas that are generated can be scribbled up for all to contemplate. A projector can point in all directions, and overwriting the projected image is possible with the white boards. As such, a high level of visual communication can be achieved. The existence of the white room as a separate entity within the overall space is heightened by a back-lit negative detail at the floor-to-wall juncture, which makes the room seem to float like a box. Furthermore, it has a cantilevered entry "portal" to reinforce the concept of entering a separate space.

The office space is like a platform, connecting information and accommodating communication. This innovative concept came from the top levels of management, with the belief that, in office design, "workspace" is unnecessary. The office was conceived as a place for communication and high performance meetings. Resonance Platform is an experimental space for a new way of working.

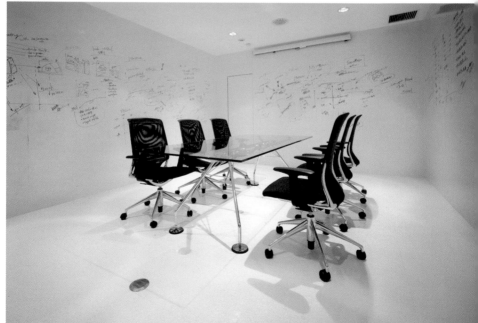

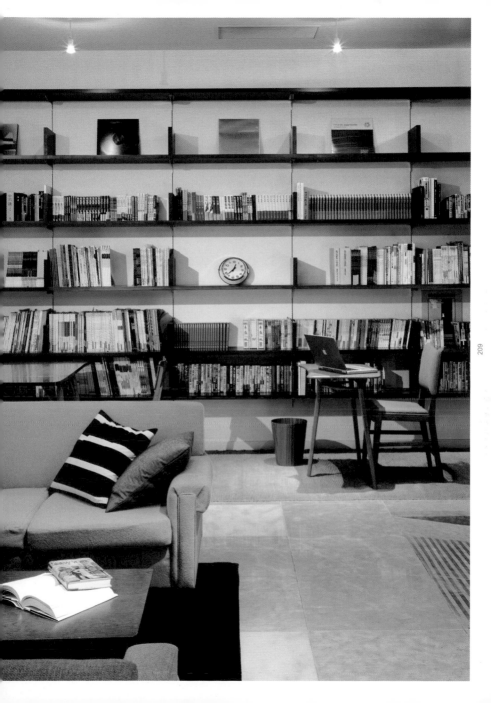

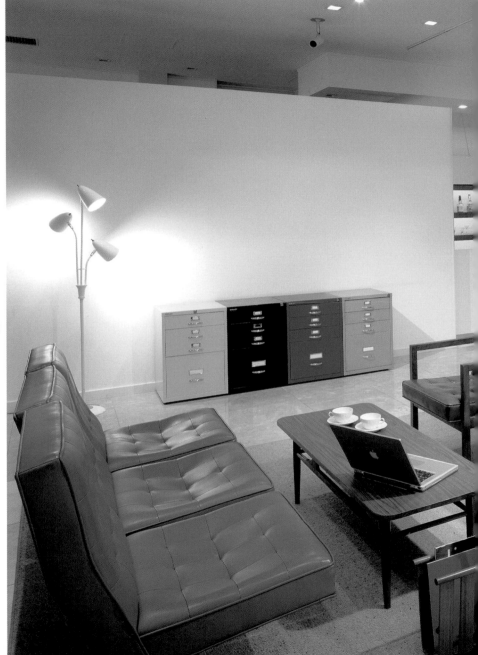

NATURALLY VENTILATED

domain resources

A naturally-ventilated main entry lobby and a "disguised" conference room are two features of this office for Domain Resources.

NAME OF OFFICE **DOMAIN RESOURCES**
OWNER/CLIENT **DOMAIN RESOURCES SDN BHD**
ARCHITECT/DESIGNER **C'ARCH ARCHITECTURE AND DESIGN SDN BHD**
PHOTOGRAPHER **GERALD LOPEZ AND AHMAD SABKI**
TEXT **RICHARD SE**
LOCATION **PETALING JAYA, SELANGOR, MALAYSIA**

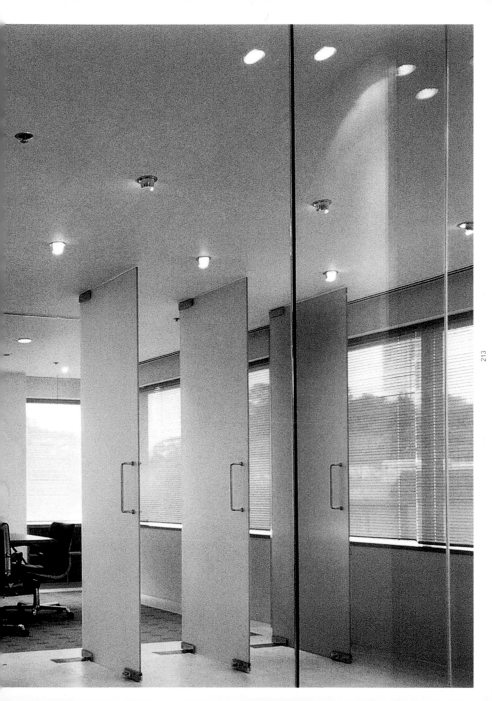

The main lobby is a generous double-volume space with a small gallery at the mezzanine level. The decision was made to retain the space as a naturally ventilated environment so the transition from the street into the building is gradual. This idea retains whilst enhances the spatial quality of the original lobby. The main entrance was left completely open, and specially developed glazing details were used to allow breeze to flow through the lobby. Perforated metal panels are clipped to the front to act as rain and sun shields. The glazed units were developed in conjunction with a glazing specialist.

The office is split into three zones: a public front for customers, a semi-public executive area for management and visiting consultants, and general offices for staff, all of which are accessible from each other. The public front begins at the lift lobby, from which the reception space is clearly visible through a large panel of glazing. Adjacent to the reception, alongside the external wall are some small discussion rooms. Accessible from the reception space is the semi-public executive area. This area consists of a large conference room, library, the Director's suites, accounts, offices, research and development offices and secretarial posts.

There are two points of entry into the executive area. The first comes via a door to one side of the reception counter, which leads directly into an executive corridor and rooms on either side. The second, less obvious entrance, comes via an over-sized curved timber door. It is seemingly disguised as part of a series of curving wall panels that open up directly into the conference room. The curved door has no handles or other clues to its purpose in order to retain a degree of privacy and mystery in this area.

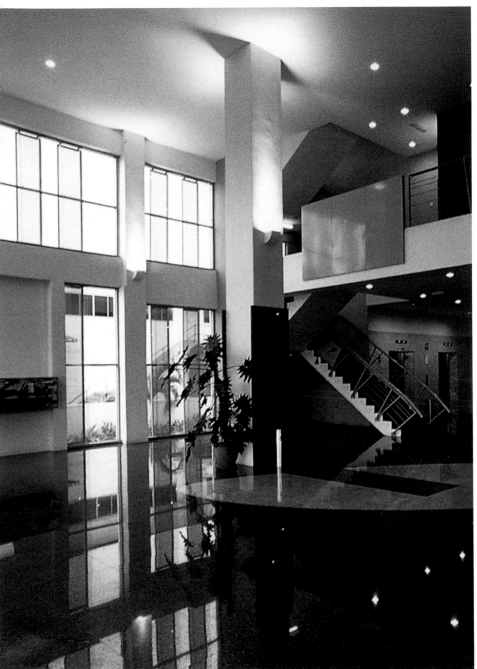

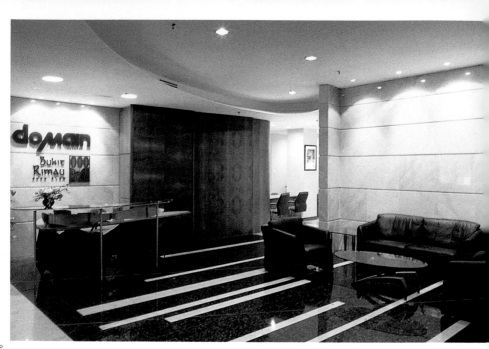

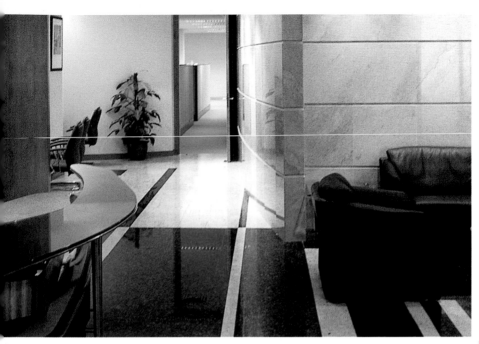

FLOATING BOXES

mukhriz
office

For this office fit-out project in Plaza Mont Kiara, the designers were asked to provide an office with an unconventional appearance. The result is a composition of "boxes" that seem to float.

NAME OF OFFICE **MUKHRIZ**
OWNER/CLIENT **MUKHRIZ**
ARCHITECT/DESIGNER **UNIT ONE DESIGN SDN BHD**
PHOTOGRAPHER **HILTON PHOTOGRAPHERS SDN BHD**
TEXT **RICHARD SE**
LOCATION **KUALA LUMPUR, MALAYSIA**

In this Kuala Lumpur office, rooms that are segregated from the main office space, such as the Executive Director's Room and the Library and Equipment Room, appear as "boxes" floating within the confines of the white-painted existing concrete structure. They are held in a taut composition by a framework of black-painted steel I-section elements. These box-like rooms are enclosed by walls that vary in their level of transparency, ranging from solid and opaque, to semi-transparent, to completely see-through. Raised off the ground by a negative detail at the floor-wall junction, they take on an apparently weightless appearance. The boxes float beneath a sea of exposed structure, services and construction details, which are expressed as design elements. The original drop-ceiling was removed so that the height of the space could be maximised.

The most highly-articulated of these box-rooms – the Director's Room – is expressed as a figurative slatted-timber box floating on a black steel frame, and wrapped with glass. The slatted surface gives a 3-dimensionality to the usually 2-dimensional wall surface. There is a glass panel at the eye-level of the seated Director, to allow for observance of the surrounding environment. A wall segment rendered with specialist blue plaster completes the enclosure of this room. Glass walls and doors segregate the rest of the space, allowing a high degree of visibility. Translucent white roll-up blinds are installed at some windows so that the degree of transparency can be varied.

A skewed timber-clad screen re-orientates the circulation axis to usher people into the Conference Room. As the single non-orthogonal element in the scheme, it signifies the different public function of this space. The screen punches through the enclosing glass wall of the Conference Room in a dramatic gesture. It features an inset panel of timber carved with floral motifs. There is also a sliding conference presentation wall in this room.

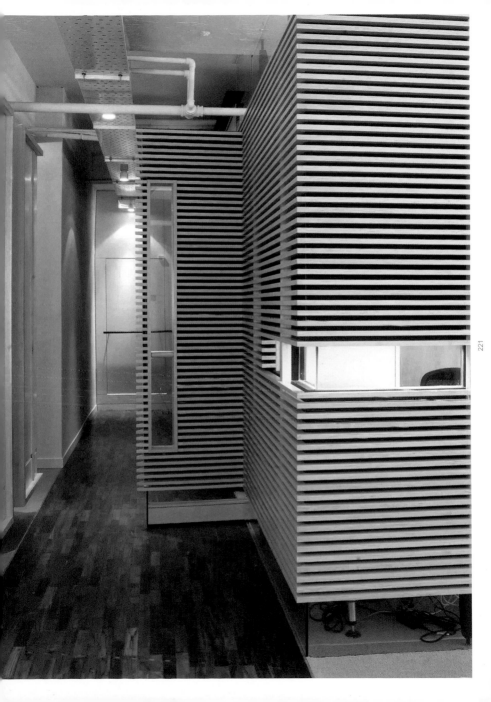

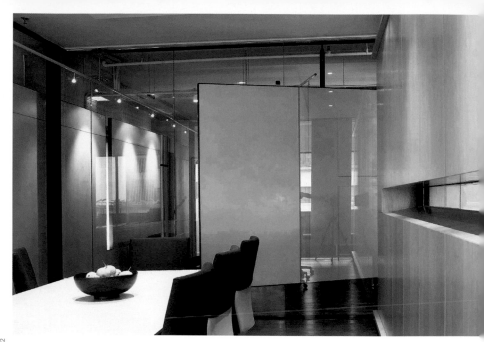

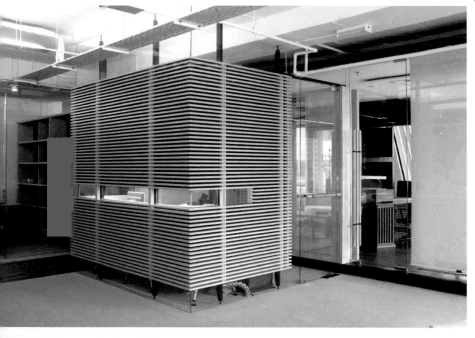

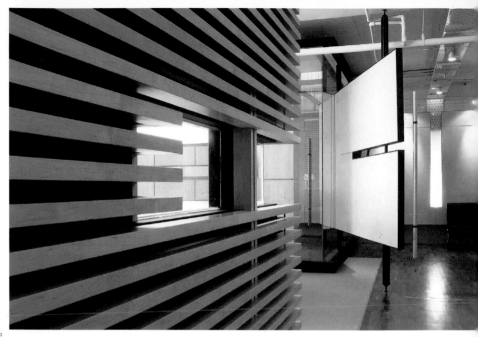

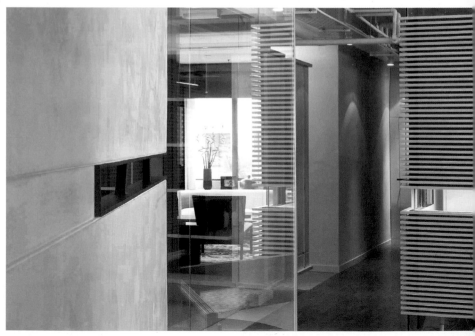

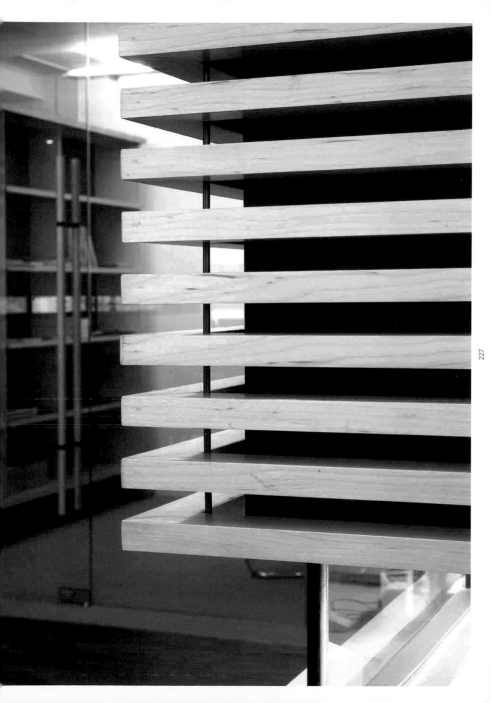

NEW WORK CULTURE

accenture

Accenture is one of the world's leading management and technology services companies. The company has adopted "hoteling" as a new way of working. ECO-ID Architects have provided the company with a new type of office space to accommodate their innovative working methods.

NAME OF OFFICE **ACCENTURE SINGAPORE**
OWNER/CLIENT **ACCENTURE PTE LTD**
ARCHITECT/DESIGNER **ECO-ID ARCHITECTS AND DESIGN CONSULTANCY PTE LTD**
PHOTOGRAPHER **KELLEY CHENG**
TEXT **NARELLE YABUKA**
LOCATION **NORTH BRIDGE ROAD, SINGAPORE**

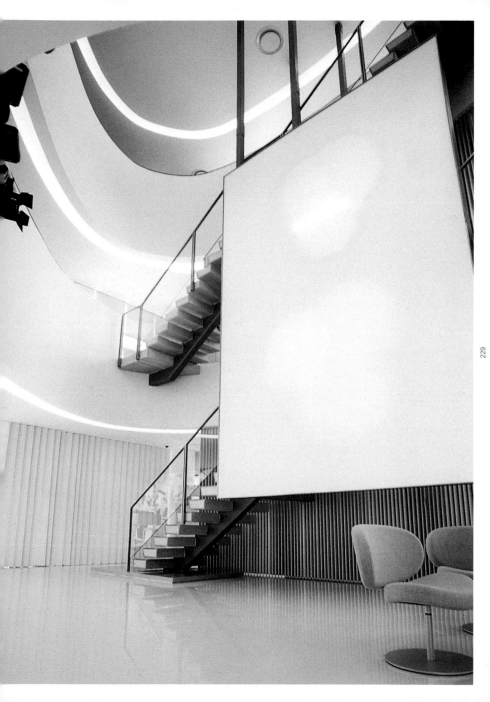

The Singapore office of global consultancy firm Accenture employs a "hoteling" system in its workplace design, as more than half the staff service clients on site – which thus reduces the utilisation of permanent workstations. Hoteling provides a "mobile" workplace that operates on a system of space reservation, allowing greater flexibility in accommodating headcount changes, as well as substantial savings on office rental and equipment costs. The staff, who do not have permanent desks, are issued mobile pedestals to store personal items. Coordinators on every floor provide technical and contact support for all staff and guests. In such an office environment, where individuals move around much like free molecules in air, effective "social" spaces where staff can interact with each other are a definite requirement. Provision of these spaces was a fundamental element of the challenge for ECO-ID.

Pockets of social spaces have been eased into an otherwise regularly structured office layout. Occupying 6 storeys of prime high-floor space at Raffles City Tower, the middle floor was designated the social heart of the office. Much of the office's main energy and activities are generated along this floor, where the reception, mailroom, staff lounges, conference and meeting rooms, and recreational facilities are located. When one enters, an atrium punctuating 3 levels of floor space forms a signature point of arrival, drawing a busy interchange of circulation paths and visual intersections. A giant projection screen extends off the staircase, upon which images are projected through the day, bathing the entire arena with a variant atmosphere that is ephemeral and enlivening.

A staff lounge adjacent to the atrium is equipped with LAN points and comes with a floating bar, forming an alternative workspace. The bold use of colours and environmental graphics elaborates the dynamic and progressive work culture of Accenture. On the same floor there are various conference and meeting rooms, linked up by a circulation avenue that is interspersed with "activity zones" characterising various sections of the avenue. On the rest of the floors, work neighbourhoods comprising open plan workstations, enclosed workrooms and project team rooms encircling a core of lift and utility services define the physical office infrastructure.

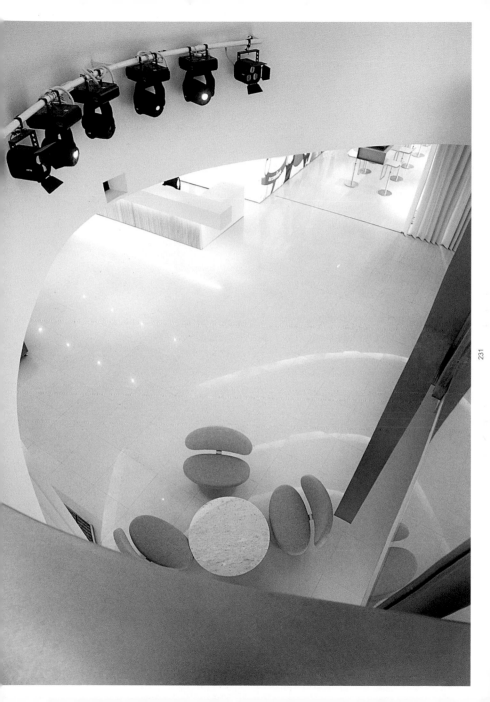

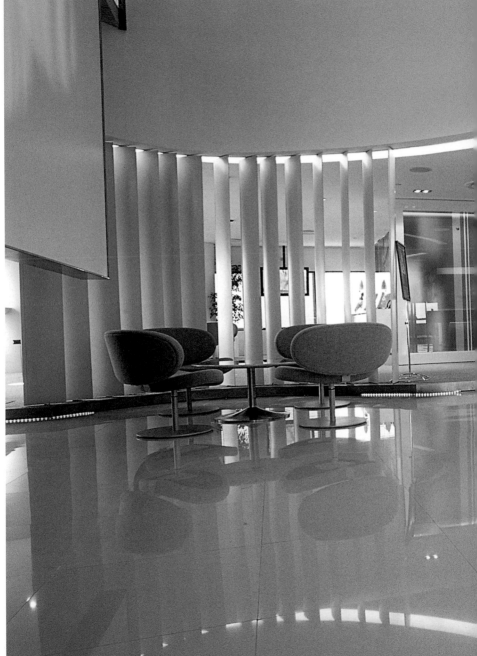

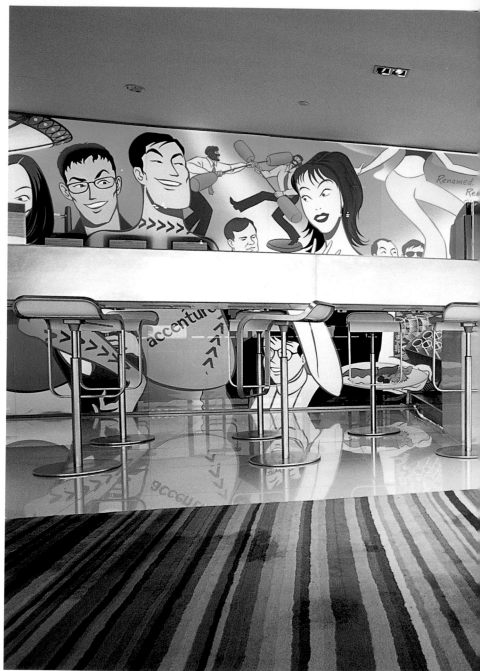

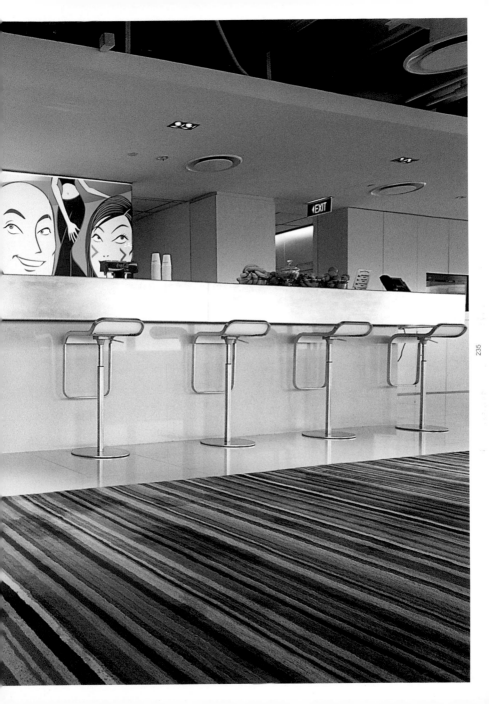

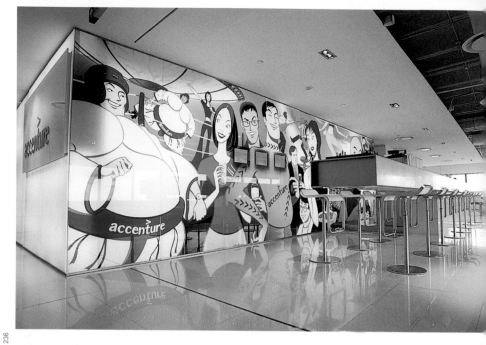

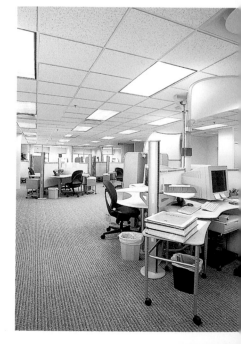

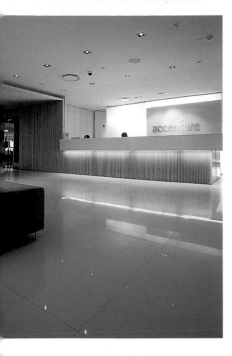

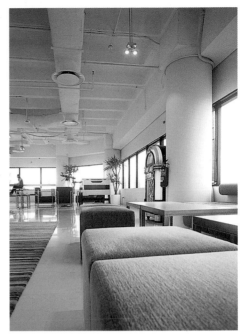

DIVERSIY AND COLLECTIVITY

edgematrix

New telecommunications technologies have ushered in an exciting wireless era where communication can take place anytime, anywhere. The office of communications company EdgeMatrix embodies the concepts of diversity and collectivity that underlie the company and its work.

NAME OF OFFICE **EDGEMATRIX**
OWNER/CLIENT **EDGEMATRIX PTE LTD**
ARCHITECT/DESIGNER **FORUM ARCHITECTS**
PHOTOGRAPHER **GEOFF ANG**
TEXT **NARELLE YABUKA**
LOCATION **HILL STREET, SINGAPORE**

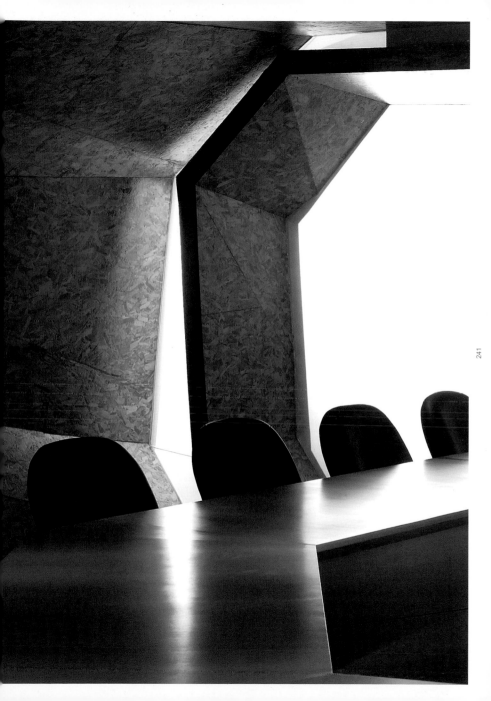

EdgeMatrix is a pioneering Singapore-based company offering infrastructure technology products that facilitate multi-channel communication. For their new office, designed by Forum Architects, the company wanted the space to reflect "a world of pervasive access through a diversity of devices that work in concert to facilitate communication and commerce regardless of location or time." Focussing on the concept of the "edge", the designers have provided a "matrix" of objects and planes that work together to create a highly communicative space.

Beyond the shell of the existing building, one is hard-pressed to find 90-degree angles in the EdgeMatrix office. It is filled with angled walls, often with fragments cut away, as if a child had taken to the space with a big pair of scissors. The visitor is alerted to the fact that this is not a conventionally-designed space as soon as they enter the reception area; a sculptural reception desk with an angled steel inset to its front face sits proudly in front of a blue wall. A slanted transparent glass screen bearing the company logo separates the workspace from the reception area. The glass panes with which it is composed are frameless, suspended instead by screw fixtures. This simple treatment reflects the boundlessness of the technology that EdgeMatrix promotes. Next to the reception, a fin of angled glass leads the eye towards the focal point of the office: the "Cave".

The "Cave" is a meeting/conference room enclosed by multi-faceted surfaces that wrap around the space, stepping back from each other as they progress, like the shell of a crustacean. Multi-faceted both in form and surface, these continuous bands of folded surface are constructed with panels of aggregate material, so they are highly visually textured. At the entrance to the "Cave", the surface protrudes past the frosted glass entry door to create a "mouth" to the "Cave". This matrix of objects and edges that Forum have created constitute a highly communicative space that is entirely appropriate for a communications company.

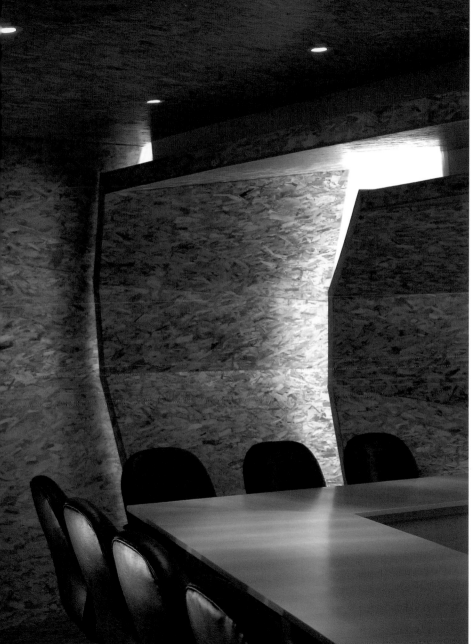

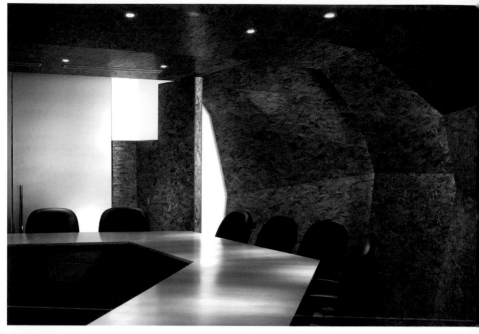

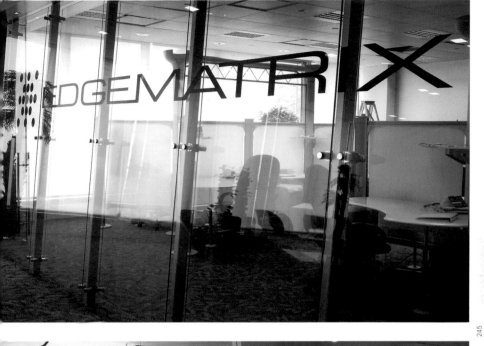

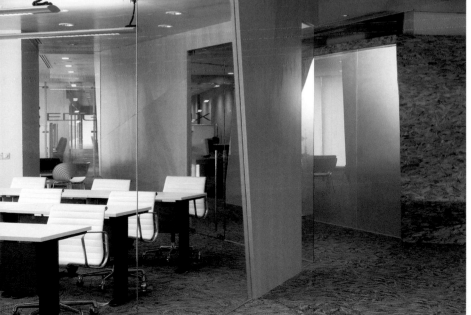

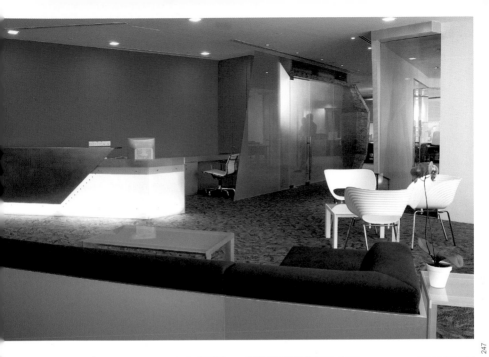

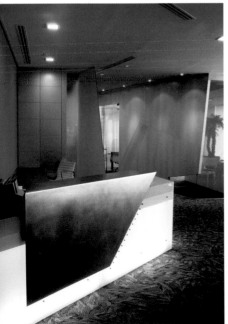

ARTISTIC CHOREOGRAPHY

glastech

This office, for a property development company who once were glassmakers, is an elegant composition of planes and materials containing a choreographed display of art work.

NAME OF OFFICE **GLASTECH**
OWNER/CLIENT **GLASTECH INVESTMENT PTE LTD**
ARCHITECT/DESIGNER **SOO CHAN/SCDA ARCHITECTS**
PHOTOGRAPHER **PETER MEALIN**
TEXT **NARELLE YABUKA**
LOCATION **SUNTEC CITY TOWERS, SINGAPORE**

The core business of Glastech is property development, but the conceptual design of this corporate office was intended to make reference to the company's roots as glassmakers. In addition, the directors of the company are avid art collectors. Art works are an important element in the choreography of the spatial experience in the office. Advancing from the lift lobby into the reception area, the axis shifts slightly to the right and one's eye is attracted by a somewhat florid painting by James Rosanquist, which dominates one wall. Drawn towards this canvas, another painting, this one by Frank Stella, appears by one's right elbow. Turn around through 180 degrees and a work by Toko Shinoda occupies the opposite wall. One thus progresses almost as one would in an urban context by reference to axis, nodal points and notable objects, highlighted by concealed lighting. The idea of deflection and dominance of one route over another is conveyed by the placement of planes and by a related pattern of lines on the floor.

The Glass Blower, an iconic life-size figure by Rossa Serra, which was specially commissioned for the project, powerfully signifies the company's origins as glass traders. But more significantly, the muted palette of white paint, polished black granite, grey and beige terrazzo floors, anigre timber, etched glass and brushed matt steel demonstrates a concern for materiality. The corporate image is reinforced by the selection of contemporary re-issues of modern classic furniture in black leather and stainless steel.

The architect's role here has been to create the understated neutral background to showcase the art works and designer furniture. But Soo Chan goes beyond this practical requirement and supplies a gestalt composition of planes and materials that foregrounds the elegant spatial qualities.

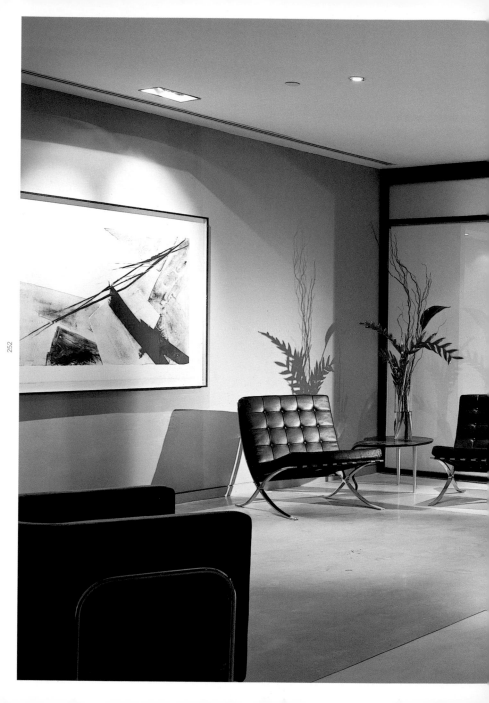

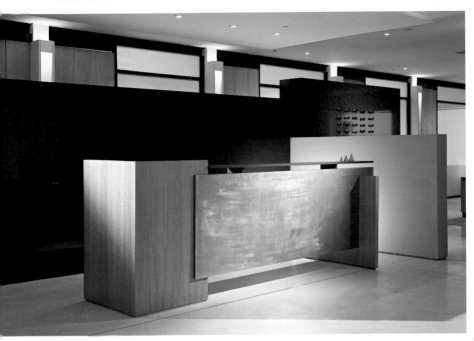

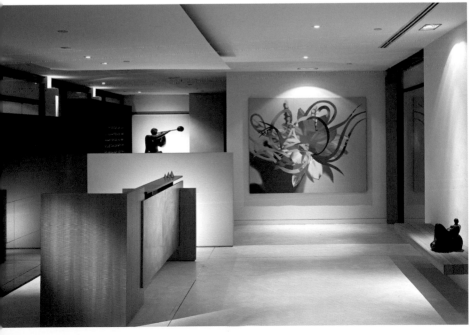

CLEAN AND REFRESHING

network technologies

Network Technologies designs Internet security software. They wanted an open office space that would reflect clear communication between all departments. Using daylight as the biggest tool, the designer has created an office space that is simple, functional and refreshing.

NAME OF OFFICE **NETWORK TECHNOLOGIES**
OWNER/CLIENT **NETWORK TECHNOLOGIES**
ARCHITECT/DESIGNER **GREG ELLIOT/CLEAR CONSULTANTS**
PHOTOGRAPHER **KELLEY CHENG**
TEXT **NARELLE YABUKA**
LOCATION **SINGAPORE**

The common mental image that comes to mind when faced with the word "technology" is one of metal, computers and sterile conditions. The Network Technologies office, however, presents a clean and fresh image. With high ceilings and lots of daylight, the design of this office provides a refreshing, open feeling for a professional, efficient organisation. The major tool of the space, daylight, was fully utilised and brought into the office. The office contains three sections – entrance, work area and cafe – that are physically, but not visually, divided by means of glass screens. Workstations are enclosed by low partitions so as to maintain an entire office space in which people can interact.

At the entrance, one is greeted by the long stretch of a glass screen, which is composed of panes of frosted and clear glass. This conveys a message of security, thus echoing the services that the company provides. There is a similar glass wall panel at the rear of the office, which enables light to travel into the work area. Another glass wall encloses the call centre. Containing noise, it still allows a visual link with the rest of the workspace. The kitchen is a spacious area towards the rear of the office space. With its stainless steel countertop, bar stools and chairs, it also serves as an informal meeting area. A balcony outside overlooks the neighbouring buildings.

The predominant colour palette is marine blue (the corporate colour). Bleached maple fittings add a softer touch. The conference/AV room is carpeted in grey. Two additional rooms, equipped with moveable panels, increase the flexibility of the space for functions or events. The main lighting system for the office consists of floodlights that wash light over the white ceiling, augmenting the feeling of brightness and loftiness. For the focused light required by work, recessed lights are built into each workstation.

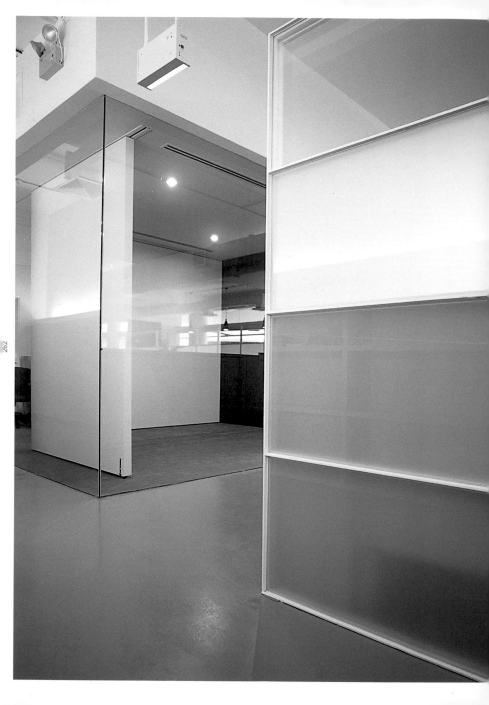

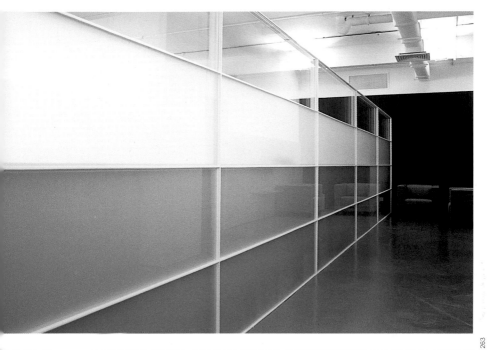

CONTEMPORARY AND CHARISMATIC

newasia

The designers at Wide Open Spaces were delirious when NewAsia gave them free reign in fashioning their office space into a blend of the East and the West. They devised a space that is at once contemporary and charismatic for this company that produces and carries "East-Meets-West" products.

NAME OF OFFICE **NEWASIA**
OWNER/CLIENT **NEWASIA**
ARCHITECT/DESIGNER **WIDE OPEN SPACES**
PHOTOGRAPHER **KELLEY CHENG**
TEXT **NARELLE YABUKA**
LOCATION **SHENTON WAY, SINGAPORE**

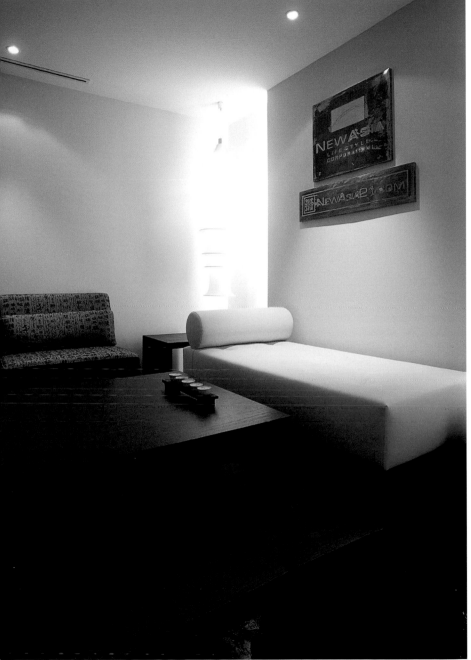

A fusion of cultures, if not handled sensitively, could appear unappetising and jarring. The design of the NewAsia office, however, with its witty use of materials, adornments and textures, is a treat to the senses. Wide Open Spaces have set the mood in the lobby area with a split bamboo mat, a rustic day bed, square dark timber coffee tables, and a seat upholstered with Chinese fabric. The NewAsia signage is an oxidised metal plaque, reminiscent of what one might see at the entrance of an old Chinese shophouse. Next to the reception sit two large urns holding dried bamboo, and surrounded by pebbles.

This Japanese influence is carried through to the sliding translucent-glass doors that are articulated with grids, much like Japanese *shoji* screen doors. These screens help to separate the directors' rooms, the "retreat" room and the conference rooms from the workstations that hover in the centre of the office space. Spatially, the configuration of this office is standard. What makes it such a delight, however, is the ingenious way that materials have been applied, and the little finishing touches of fronds, colourful sandalwood incense and wooden tea-light holders that are placed all around the space. Conceptually, these elements bounce off industrial materials, such as perforated metal sheets, in a captivating way. The perforated metal sheets are used to back the industrial shelving units that section off the accounts department, and as privacy shields for the managerial "cubicles".

The floor is finished in simple epoxy paint, which is dark grey in colour. All workstations are composed of dark-stained wooden tables and steel cabinets, further expressing a fusion of old and new, craft and industry. The "retreat" room is a lounge with dark timber bar stools lined up along a bar that offers a view through large windows. A daybed gives the feel of a cosy studio apartment. A "monumental" iron Buddha head sits in one corner of a conference room, presiding over every discussion, and perhaps prompting careful contemplation of every decision. Wide Open Spaces have succeeded in bringing out the dynamic opposing paradigms of the East and the West, reflecting the aims of NewAsia, which engages in the directions of the "new economy", while maintaining links with the "old".

NOTHING LEFT TO CHANCE

orange brand communications

Orange Brand Communications is a company that delivers branding consultancy services. Its new Singapore office offers premises that are perfect for showcasing the value system of the young setup.

NAME OF OFFICE **ORANGE BRAND COMMUNICATIONS**
OWNER/CLIENT **ORANGE BRAND COMMUNICATIONS**
ARCHITECT/DESIGNER **GREG ELLIOT/CLEAR CONSULTANTS**
PHOTOGRAPHER **PETER LAU**
TEXT **NARELLE YABUKA**
LOCATION **BEACH ROAD, SINGAPORE**

The clients specifically demanded a design scheme where nothing is left to chance – one that subtly communicates the idea of good design. Located in a high-rise office tower, the site offers stunning views to the city and the sea. The design response offers a high-degree of transparency to maximise the views, as well as provide a high level of interaction between employees.

The company's corporate colour – acid green – adorns a feature wall at the entrance. Acrylic rods of a 100 millimetre diameter are inserted into another wall adjacent to the entrance, forming a display feature, as well as a canvas for the free expression of the employees. Representing the trendsetting culture of a creative agency, the entrance passageway is back-lit and colour-corrected, allowing for graphics to be adhered onto the surfaces so that an ever-changing and dynamic visual environment can be created. Various types of flooring materials are used to denote areas of specialisation – carpet is used in the administrative department, stainless steel flooring adorns the creative department, and timber flooring has been used in the managers' offices.

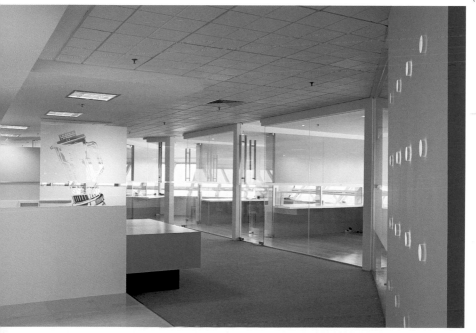

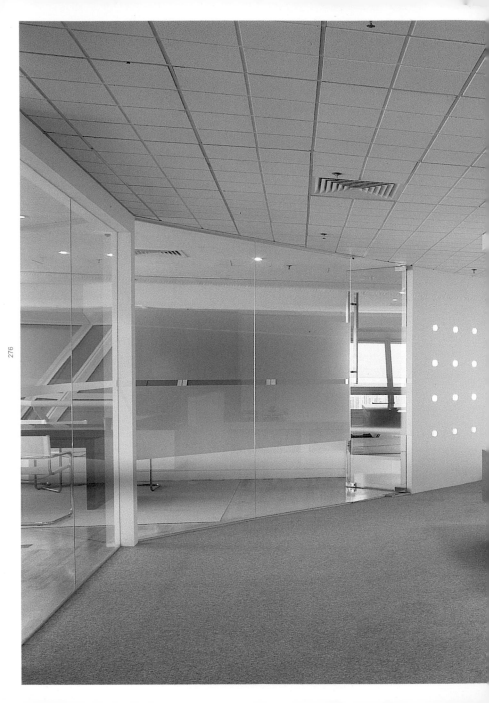

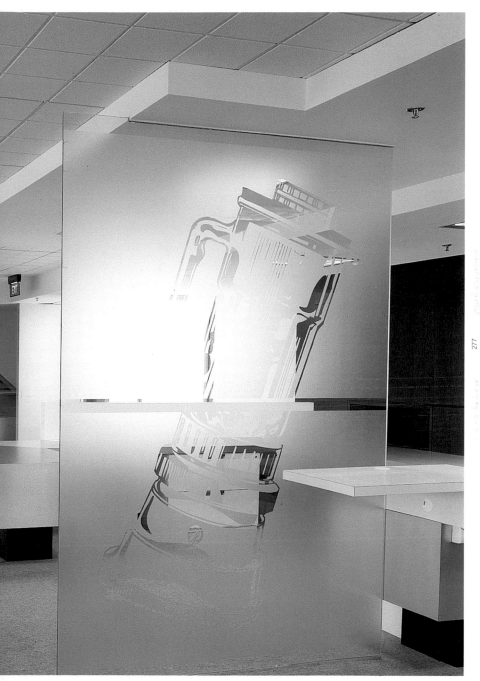

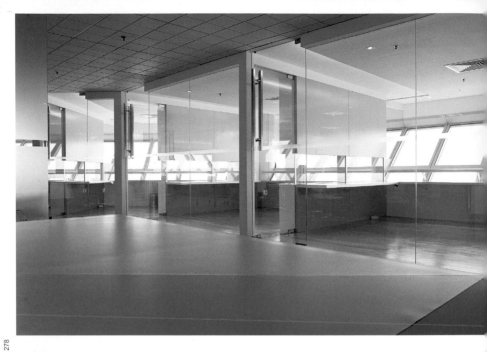

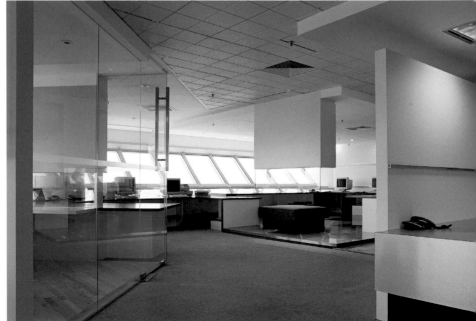

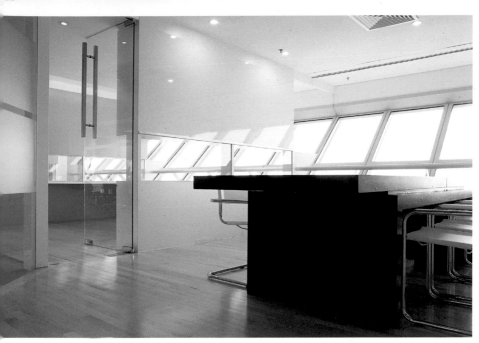

IN THE RAW

saatchi
& saatchi

Greg Elliot of Clear Consultants has used the concept of rawness in his design for the Singapore office of Saatchi & Saatchi. Located in an old shophouse, the office exudes raw energy and the sense of "quality" that is synonymous with the company.

NAME OF OFFICE **SAATCHI & SAATCHI**
OWNER/CLIENT **SAATCHI & SAATCHI**
ARCHITECT/DESIGNER **GREG ELLIOT/CLEAR CONSULTANTS**
PHOTOGRAPHER **KELLEY CHENG**
TEXT **NARELLE YABUKA**
LOCATION **CLARKE QUAY, SINGAPORE**

Saatchi & Saatchi provided Elliot with a very basic brief, asking only for an "honest representation of the company". There is little that could be more honest than stripping the floors bare to expose the most raw of all building materials – cement screed. He has reinstated the timber frames of the original shophouse windows, and banished false trimmings of any nature. Walls and ceilings are composed of simple white plasterboard, and service ducts are exposed in places. The aesthetic is raw, but in the office environment, it is extremely seductive.

In the crisp, but welcoming, entrance lobby, the materials that are so deftly applied throughout the office are used to achieve a contrasting palette of colours and textures. A roughly-textured wall constructed with antique bricks hints at the surprises that beckon further within. This is a serious enterprise, but advertising being advertising, Saatchi and Saatchi thrives on the concept of "work and play". There lies beyond a workspace that abounds with a playful use of maple strips that create three distinctive screen walls. These screens represent the three teams that work within the space, and have thus been configured with identifiable patterns; one uses horizontal strips, one has a grid configuration of strips, and the other looks like a game of "pick-up sticks".

If the irrational geometry is used to define "play", then the reverse condition of rational elements speaks of "work". The work zone is based on an open concept with shelves, racks and workstations serving as low and porous partitions – all of which define a basic geometry allowing each member of the staff to liberally infuse their space with their own personal character. A reinforced concrete wall has been inserted between the work area and a boundary wall to create an "alley" zone in which the photocopier is situated, and to which staff can retreat for a meditative break; one could get lost for hours in the patterns on its surface. With no pretences and no false fronts, this office is understated, and yet indescribably appealing and delightful to the senses.

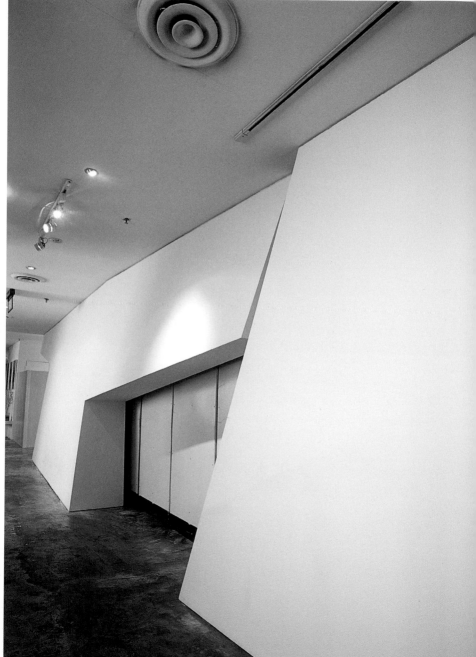

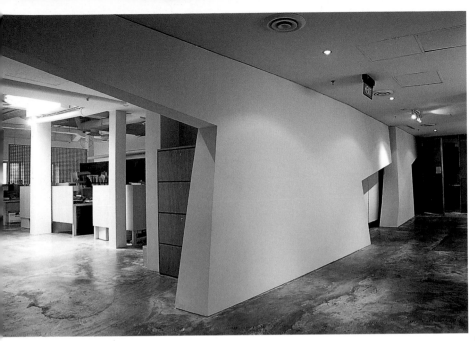

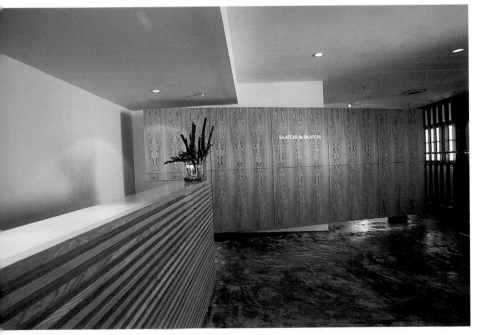

ELEMENTAL EXPRESSION

scda office

Clarity in construction details and a sense of elemental architectural expression are the guiding principles behind the design of this office for an architectural firm. Surfaces and volume, darkness and light are all carefully composed to offer a 3-dimensional advertisement of the firm's style.

NAME OF OFFICE **SCDA ARCHITECTS PTE LTD**
OWNER/CLIENT **SCDA ARCHITECTS PTE LTD**
ARCHITECT/DESIGNER **SCDA ARCHITECTS PTE LTD**
PHOTOGRAPHER **KELLEY CHENG**
TEXT **NARELLE YABUKA**
LOCATION **TECK LIM ROAD, SINGAPORE**

SCDA is a multi-disciplinary architectural practice, offering to its clients the services of architects, interior designers and graphic design staff. Its holistic approach to architecture includes full interior design and planning services. The firm's designs strive for tranquility and an air of calmness, which is achieved through a careful manipulation of space, light and structural order. Their projects typically display sensitivity to the inherent beauty of natural materials, and a sensuous engagement with the elements.

The firm's office is situated within an old shophouse. It is an understated composition of surfaces and volumes; darkness and lightness. The interior is simple and expressive. It is in essence, a smooth, white-painted envelope, into which elements of architectural expression have been delicately inserted. In the reception area, the reception desk is itself transformed into an architectonic element. Its two separate elements of countertop and front panel seem to float above a timber floor and slide into an adjacent feature wall, which bears the company signage in small black lettering. Typical of the design of the rest of the office, nothing is overstated.

A skylit informal meeting area (the original shophouse courtyard) contains a pond featuring a sculptural terracotta pot. The roundness of the pot contrasts strikingly with the straight lines and right angles of the surrounding space. Timber slats punctuate the skylight opening. The shallow pond is lined with black tiles. The "blackness" of the water contrasts strikingly with the white interior envelope, and balances visually with the dark furniture, a black-painted overhead steel I-beam, and a black painted door beyond. An upright floor lamp softens the composition – with a warm yellow light being emitted from the rigid black-framed box of its form. This serene space blurs the distinction between the interior and exterior – a design strategy that often surfaces in the work of the firm. The SCDA office, exuding clarity and calmness, successfully bespeaks the firm's style, and serves as an excellent 3-dimensional advertisement to their clients.

SENSUALITY AND SENSIBILITY

silkroute holdings

The designers at DDA have instilled something powerful, beyond basic ergonomics, into the Silkroute Holdings office – gesture.

NAME OF OFFICE **SILKROUTE HOLDINGS PTE LTD**
OWNER/CLIENT **SILKROUTE HOLDINGS PTE LTD**
ARCHITECT/DESIGNER **DDA (DESIGNED DESIGN ASSOCIATES PTE LTD)**
PHOTOGRAPHER **KEN SEET AND KELLEY CHENG**
TEXT **NARELLE YABUKA**
LOCATION **BEACH ROAD, SINGAPORE**

Silkroute Holdings guides businesses on the web, but does not deal directly with e-commerce. This function, bordering on the concept of the "intangible", has been captured by DDA as an inspiration for the design of the office. They have used the idea of the amoeba – a formless, organic and adaptable organism – to inform their gestural design intervention. Gestures are never matter-of-fact; they are always directed towards others. Gesture seems a perfect architectural expression for this Internet company whose function is not easily described.

The company occupies two floors of an existing office building. Although the two storeys segregate the upper levels of management from the general office space, both floors are planned with similar strategies. A main "embracing" elliptical entrance foyer divides the length of the plan into two wings, which are then organised into fluid, interactive spaces. "Public" areas, such as meeting and conference rooms, are planned around the reception. Partitions between personnel, as well as between hierarchical areas, are kept to a minimum. As the upper floor caters to the directors' offices, the main boardroom and other ancillary spaces, the expression is somewhat formal and sombre. However, on the lower floor, the expression shifts to signify the dynamism and informality that are inherent in the general workforce at Silkroute.

A simple gesture of spaciousness and the careful handling of proportions in both arenas suggest a definitive attitude towards interpersonal interaction. The staff are not crammed into the space in an effort to maximise the floor space; instead, they are provided with a pleasant and spacious work environment. Spaces are intentionally planned to enhance communication and interaction through the manipulation of low and semi-transparent partitions. One of the most exciting spaces is the "chill-out zen room" on the lower floor, which is a lounge area for the staff finished in warm timber flooring. Vertical timber strips are spaced out along the corridor, acting as partitions to this "living" space. There is a recognition here that spatial gestures are as important as appropriate social and business gestures. In this space, attention is given to the sensual and visual delight of the user. With its mission to guide, what Silkroute is unable to spell out in its business contracts is clearly displayed through spatial devices in its office.

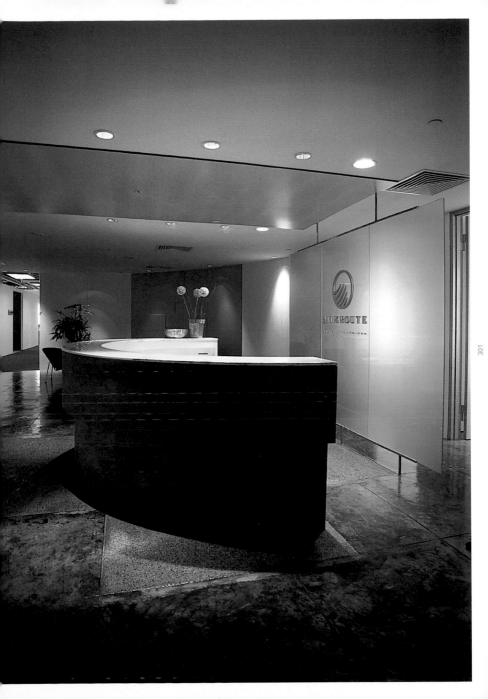

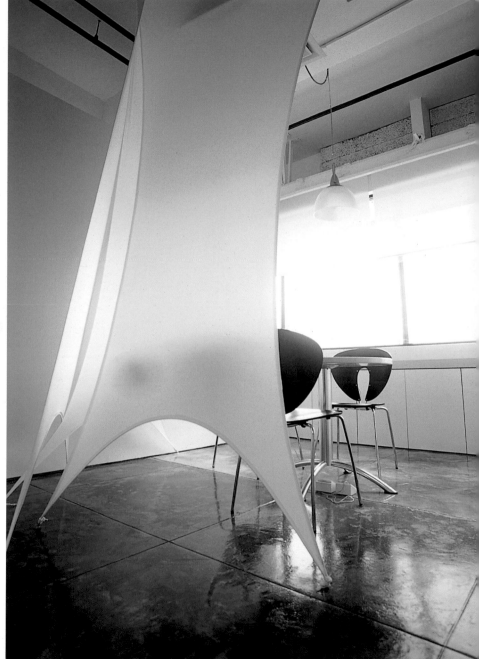

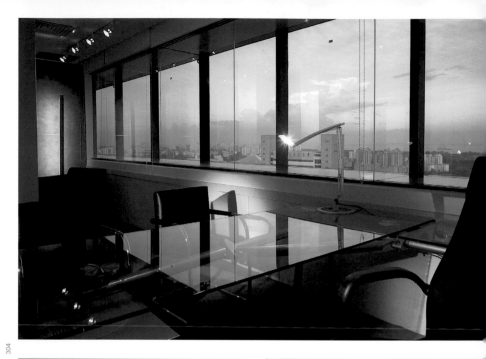

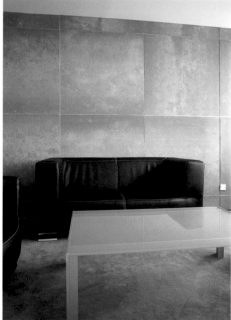

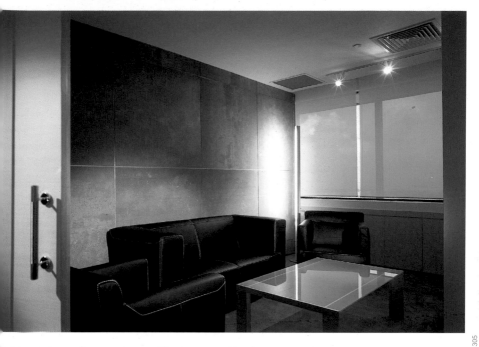

ART SCHOOL HIP

the ogilvy centre

Taking heed of the rapidly changing nature of work, and the needs of their client, Woods Bagot Singapore has created a new working "landscape" for advertising giant Ogilvy and Mather. This surprising space feels more like an art school than an office.

NAME OF OFFICE **THE OGILVY CENTRE**
OWNER/CLIENT **OGILVY PUBLIC RELATIONS WORLDWIDE**
ARCHITECT/DESIGNER **WOODS BAGOT SINGAPORE**
PHOTOGRAPHER **KELLEY CHENG**
TEXT **NARELLE YABUKA**
LOCATION **ROBINSON ROAD, SINGAPORE**

With an understanding of the creative and interactive needs of the staff
of Ogilvy & Mather (O&M), and the vibrant, creative and energetic
image that the company wishes to project to their clients, Woods Bagot
has provided an office "landscape" that is stylish, colourful, spacious
and full of surprises. The office occupies two full floors plus one lower
floor in part of the conservation-listed TAS Building. The basic plan of
the two major floors consists of a central core of creative meeting
rooms encircled by a circulation corridor, off which all office spaces
feed toward the building envelope. The core creative zone has been
dubbed "the test tube" due to the semi-circular treatment given to it at
one end, its transparency, and the inventing that goes on within.

The architects' major element of spatial manipulation was based on
O&M's concept of "360 Degree Branding", which recognises that every
point of contact builds the brand. The architectural translation of this
concept involves dealing with space in a truly 360 degree manner.
Floor slabs have been punctured so that the vertical dimension, as well
as the horizontal one, can be manipulated. The upper floor is pulled
away from the major circulation stair and edged by a glass balustrade,
so that the staircase climbs through a spatial void and there is a real
visual interaction between the floors.

There are no separate office cubicles, not even for senior staff.
Instead, they work on a raised platform at the edge of the main
departmental space. Glass partitions are the only divisive elements
between departments. The "test tube" meeting rooms are all
individually themed and named, to entice staff into a position where
they can really interact and get creative. The most outlandish of these
rooms include "The Egg Room", which contains nothing but ball-
shaped chairs, and is designed to deconstruct hierarchies; "The St
Francis Room" embodies a Godly austerity, with a concrete floor,
engraved wall, and pew-like benches and table for those times when it
is divine intervention that staff seek; "The Hendrix Room" is enclosed
only by colourful beaded curtains, and contains plastic green chairs, a
disco ball and a shag pile rug on a painted floor. It is designed to
stretch the minds of the staff, and promote brainstorming.

ORISE DEVS, ILLVMINA

ET DA MIHI FIDEM RE

CARITATEM PERFECTA

ONEM, DOMINE, VT FA

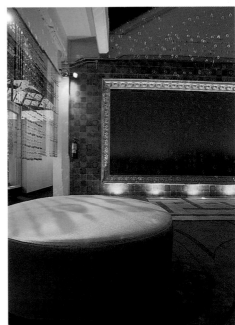

LOGGED ON

web connection

Web Connection is a relatively young web-page design company that has set out to redefine the office; that is, to create a space that you don't feel the need to "haul" yourself to every morning.

NAME OF OFFICE **WEB CONNECTION**
OWNER/CLIENT **WEB CONNECTION**
ARCHITECT/DESIGNER **GREG ELLIOT/CLEAR CONSULTANTS**
PHOTOGRAPHER **KELLEY CHENG**
TEXT **NARELLE YABUKA**
LOCATION **CENTRAL MALL, SINGAPORE**

Web Connection had specified to designer Greg Elliot that they wanted an office atmosphere that would defy the conventional "boardroom boredom". Evidently, he has succeeded in delivering such an interior – the glass-topped table in the "war room" (meeting room) has been shattered by someone who was apparently inspired enough to take their discussion very seriously indeed! The meeting room is in full view of the workspace, being separated only by a glass screen and door. Perhaps in keeping with the notion of virtual space, where no real boundaries exist and sites are linked, the workspace is partition-less.

The reception area, the most daring space in the office, is dark, broody and luring. Beside a bright red reception counter, square red panels on the floor are lit from underneath by fluorescent tubes. The corporate colours of grey, black and red make up the prevalent palette, being applied to acrylic wall panels, partitions, carpet, cabinets and shelves. Fronting the reception is a wall featuring alternating panels of black, red and transparent acrylic; it represents a physical translation of the pixellated computer screen. Black is the dominating colour, and the punctuations of red and clear acrylic allow fragmented views into the office space behind.

Despite a rather serious treatment to the space occupied by the account-management department, a sense of playfulness finds its expression beyond the reception via a strip of red neon light that appears on the built-in wall of shelves facing the production workspace.

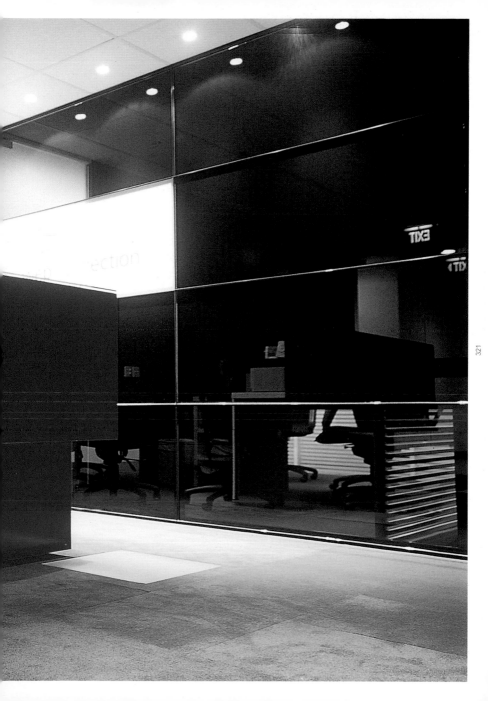

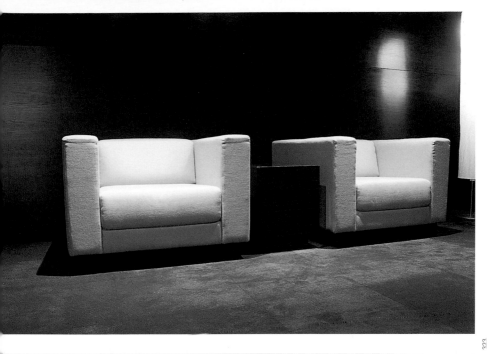

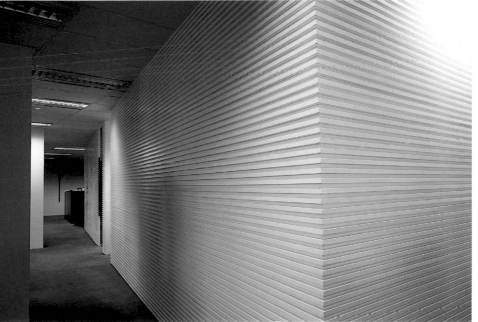

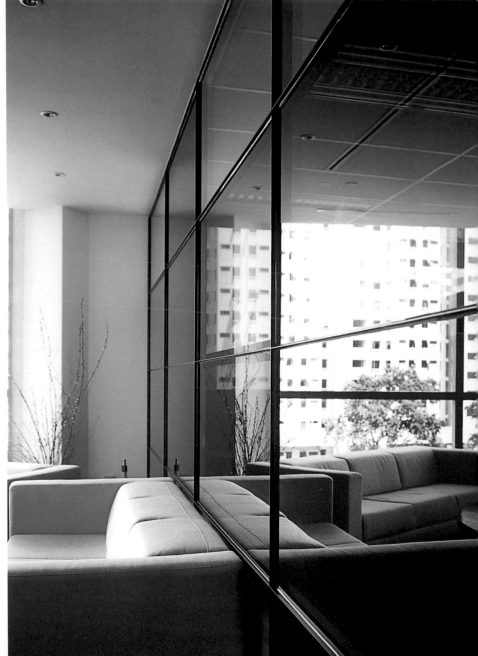

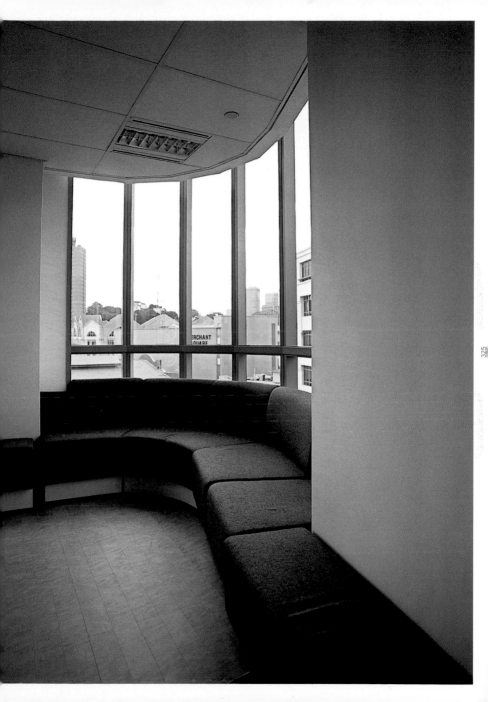

LIFESTYLE CAMPUS

greyhound
offices

Greyhound sells its clothing in department stores and in its own retail shops across Thailand. The company is rapidly expanding, adding items to its lines, outlets to its distribution network, brands to its family, and innovations to its stores (such as chic cafes). Its office headquarters are akin to a miniature corporate campus.

NAME OF OFFICE **GREYHOUND OFFICES**
OWNER/CLIENT **GREYHOUND**
ARCHITECT/DESIGNER **VITOON KUNALUNGKARN/IAW**
PHOTOGRAPHER **KELLEY CHENG**
TEXT **SAVINEE BURANASILAPIN & THOMAS DANNECKER**
LOCATION **SUKHUMVIT, BANGKOK, THAILAND**

The Greyhound headquarters are contained in a 1960s modernist house with two outbuildings, which have been renovated to form a sort of miniature corporate campus. Entrance is through a lobby-cum-informal meeting area, formerly the porch of the main house. This dramatic, clean white space is dominated by a double-height wall of clear glass louvre windows. Their elaborate opening mechanisms are the principle adornment of the space.

The main house has been thoroughly renovated to suit the needs of accounting, marketing, personnel, reception, and pattern departments. To the right of the house, a two-storey prism contains the main kitchen for Greyhound Cafes on the first floor, with design studios for the clothing department on the second floor, accessed by an open-air covered walkway from the main house. On the other side of the house is a small warehouse for Greyhound's clothing department. Locating the kitchen and warehouse in the same complex as the clothing designers and administrators is an important reflection of Greyhound's corporate structure. Even as it expands and diversifies its product line, its commitment to a focused, design-conscious lifestyle remains in place.

Siting the company's headquarters in a converted 1960s house is appropriate, and perhaps even foretelling. Greyhound's brand identity, while not strictly retro, brings to mind some of the optimistic exuberance of high modernism, when there was the feeling that design could still "save the world". Expanding to include food, and with an increasingly visible interior design component, could Greyhound furniture, homewares, and interiors be far off?

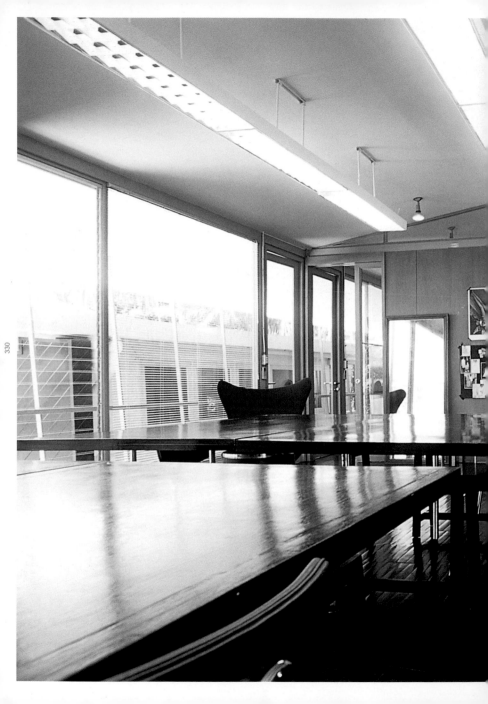

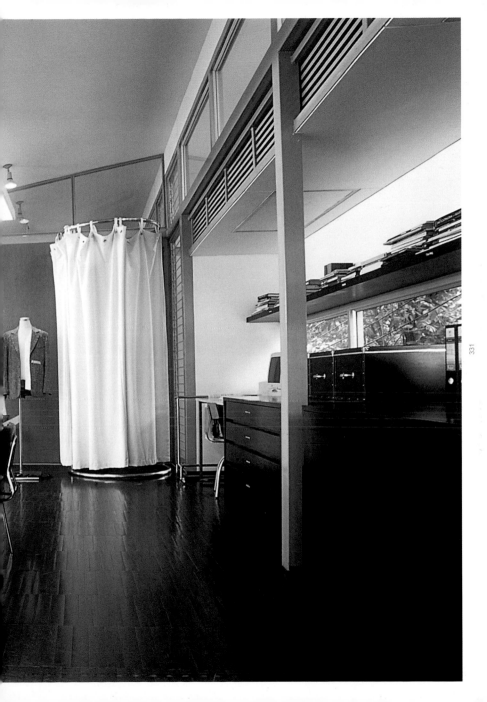

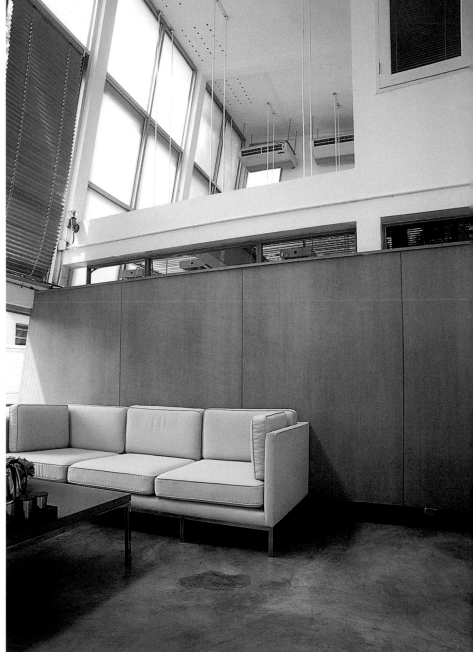

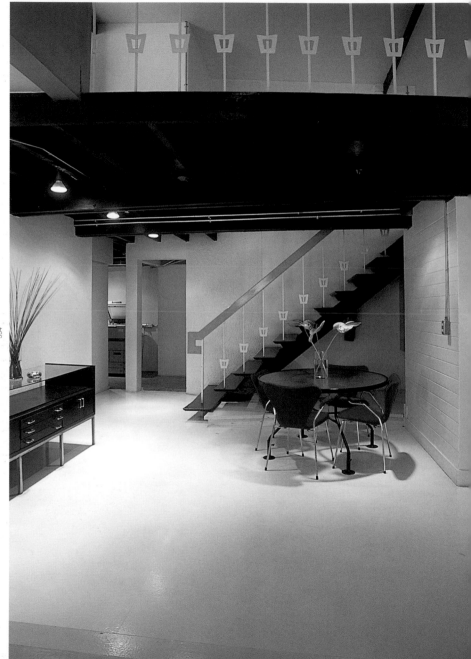

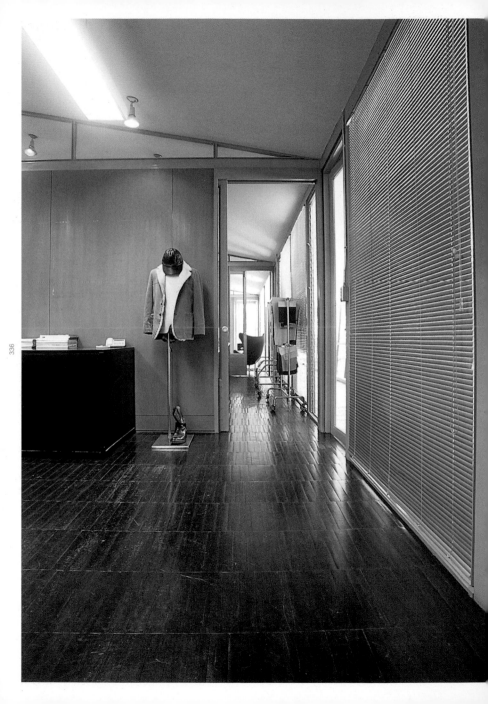

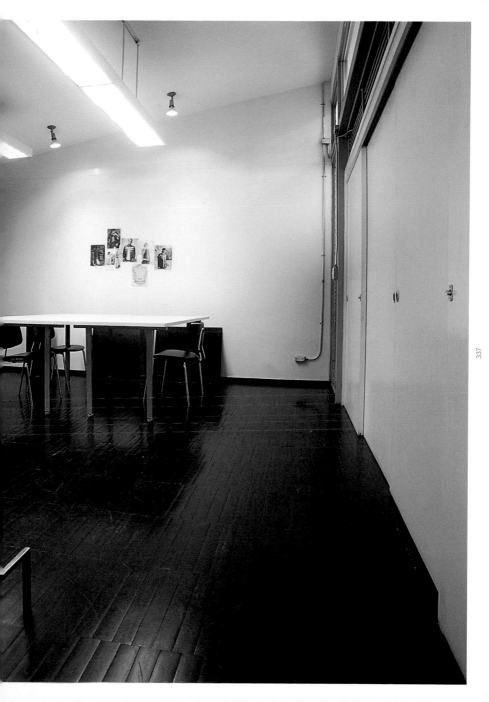

TRUTH WELL TOLD

mccann erikson (thailand) ltd

The office of the international advertising agency McCann-Erickson embodies a vibrant, youthful energy. The company's slogan "Truth Well Told" is at least as applicable to its neo-functionalist office design as to its advertising accounts.

NAME OF OFFICE MCCANN-ERICKSON (THAILAND) LTD
OWNER/CLIENT MCCANN-ERICKSON (THAILAND) LTD
ARCHITECT/DESIGNER IA ARCHITECTS 49 LIMITED
PHOTOGRAPHER SKYLINE STUDIO
TEXT SAVINEE BURANASILAPIN & THOMAS DANNECKER
LOCATION SATHORN, BANGKOK, THAILAND

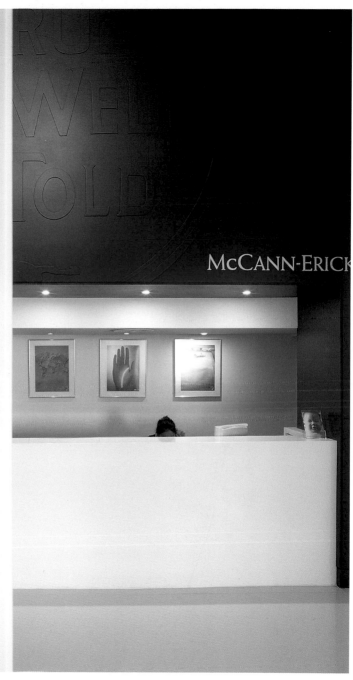

The McCann-Erickson office takes up three high floors of Bangkok City Tower, with a dramatic view overlooking the busy streets of Bangkok. One floor of administration and finance departments, and two floors of creative department, are not only well-wired to support a contemporary, technologically sophisticated office, but are also well-arranged to encourage interactivity and communication amongst the staff – a quality of the work space that both the interior designer and the owner aimed to create.

The lobby of McCann-Erickson is a double-height space facing a brilliant blue staircase, which leads to the primary meeting room on the mezzanine level – a steel structure suspended from the ceiling. Hexagonal clusters of workstations fill out the interior of the columnless expanse of the floor, surrounded by a series of smaller meeting rooms, executive offices, and shared conveniences like a resting area complete with *foosball* table (table soccer game). The upper mezzanine level places additional workstation clusters around its perimeter. The double height space not only serves as a spatial relief from the typical office environment, but dramatically alters the interpersonal dynamic of the office.

Utilising the company's logo colours of white and blue, the walls and floors act as a white canvas, onto which blue figures are applied – functional elements like metal trusses, railings, staircases, and the mezzanine structure. The overall atmosphere is of a cool, youthful energy. Pockets of common space maintain a casual, airy atmosphere created by the careful choice of fun and playful lounge-style furniture and a thoughtful juxtaposition of natural and artificial lights.

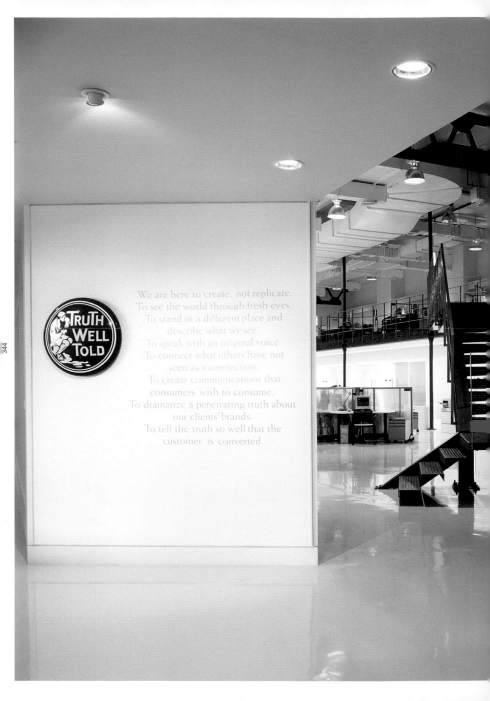

DRAMATIC DISPLAY

p interior & associates co ltd

The offices of an interior design firm are a prime opportunity to display both the talents of the designers and the furnishings that they specify. For their own office, PIA have created a "living room-cum-showroom" in which they do just that.

NAME OF OFFICE P INTERIOR & ASSOCIATES CO, LTD
OWNER/CLIENT P INTERIOR & ASSOCIATES CO, LTD
ARCHITECT/DESIGNER RUJIRAPORN PIA WANGLEE, P INTERIOR & ASSOCIATES CO. LTD
PHOTOGRAPHER SKYLINE STUDIO ORDINARY PARTNERSHIP
TEXT SAVINEE BURANASILAPIN & THOMAS DANNECKER
LOCATION KLONGTOEY, BANGKOK, THAILAND

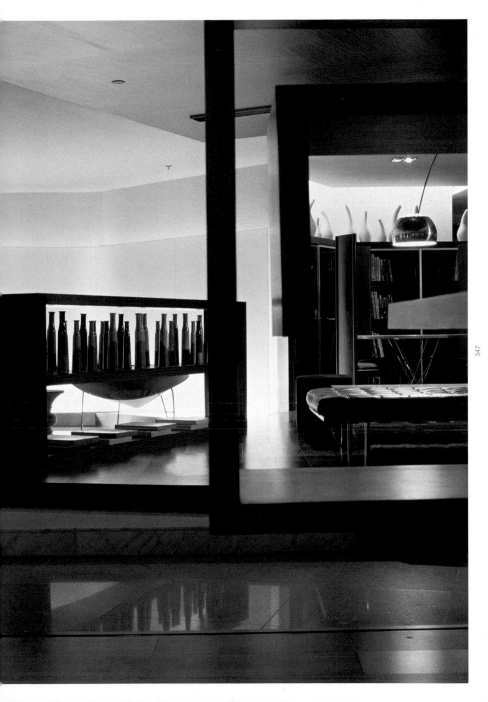

There is a dramatic entrance to the 29th storey offices that PIA designed for its own use. Visitors enter through a 2 metre wide glass door at the mouth of an austere white marble tunnel. With its raised floor and lowered ceiling, this tunnel compresses the sense of spatiality, making the offices beyond seem larger. Stepping out into the reception area, decompression is accompanied by disorientation as floor and ceiling materials erupt into non-orthogonal angles.

A reception desk is tucked away to the left. On the right is the glazed wall of a conference room with timber surfaces and book-lined walls that give it a dark, rich atmosphere, setting it apart from the more public spaces of the office. The first employees a visitor encounters, however, are likely to be having an ad hoc meeting on the raised wooden floor that juts into the reception area. The collection of domestic furniture that it holds is part "showroom" for clients, and part "living room" for the designers.

The "living room" is well placed in the office as a whole, as it touches the circulation spine that runs the length of the space from one main partner's office to the other. In between are the workstations of the firm's employees. Placing occasional-use programmes (reception, conference, printing, and so on) towards the building's core gives almost every worker a prime location a desk or two away from the windows, which offer a dramatic panorama of Bangkok. Tall wooden partitions are used to screen workstations from public view, as the desktops beyond exhibit the messy vitality of a creative firm with a lot of work on its hands.

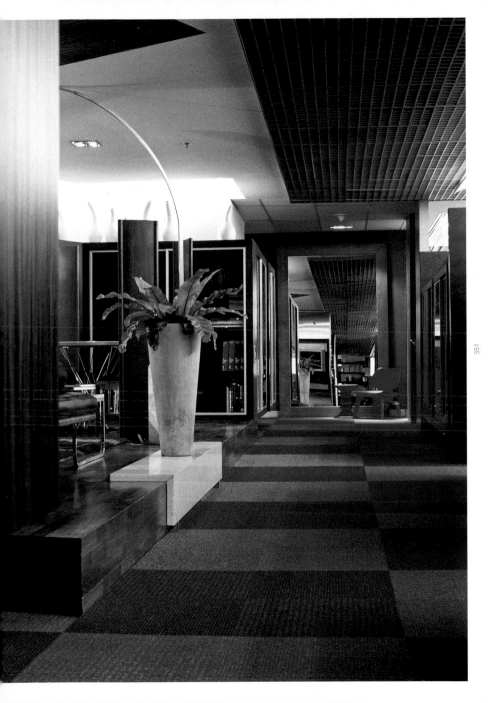

ADVERTISING, GRAPHIC & INTERACTIVE

18th floor sc matchbox co ltd

SC Matchbox Co, Ltd is one of only two Thai-owned advertising firms. They offer services in advertising, direct marketing, graphic design, multimedia, event marketing, and consumer research. Combining local insight with professionalism of an international standard, SC Matchbox is well poised to operate in the hyper-complexity of Bangkok, and the design of their office shows it.

NAME OF OFFICE SC MATCHBOX CO LTD – ADVERTISING, GRAPHIC & INTERACTIVE
OWNER/CLIENT SC MATCHBOX CO LTD
ARCHITECT/DESIGNER ARCHIPLAN CO LTD
PHOTOGRAPHER KELLEY CHENG
TEXT SAVINEE BURANASILAPIN & THOMAS DANNECKER
LOCATION PHAYATHAI, BANGKOK, THAILAND

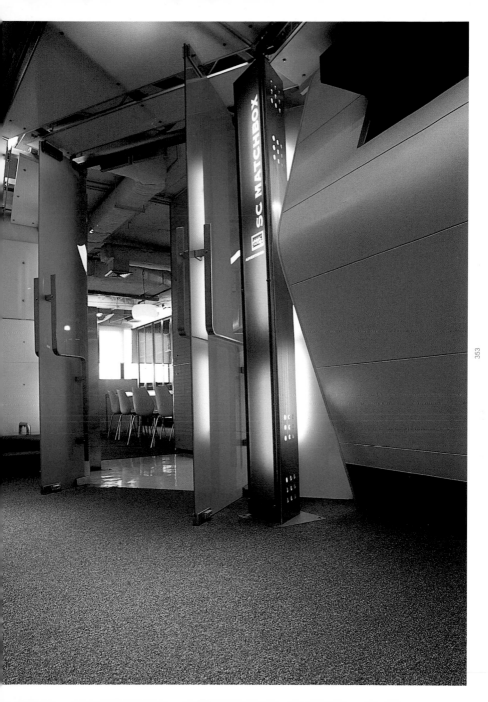

SC Matchbox uses the 18th floor of its offices as a creative hub. Stepping off of the elevator, visitors do not find themselves in a formal corporate lobby, but right in thick of the creative "mess" – in the library used by the firm's advertising and Graphic/Interactive Departments. Waiting for an appointment in the adjacent glass-walled meeting room, one cannot help but rub elbows with coffee-sipping designers as they browse magazines and books for inspiration and raw material.

A countertop with bar stools floats before the window. Transposed from the storefront of a coffee shop to the 18th floor, it does not face the typical view of a microcosm of street activity, but a view of the bigger picture – skytrains and skyscrapers, highways jammed with traffic, billboards and neon lights. One of only two Thai-owned advertising firms, SC Matchbox is well poised to operate in the hyper-complexity of Bangkok, and their architecture shows it.

A total of 130 employees work on this floor, and Archiplan's innovative renovation solution was to decrease the space allotted to each one. The typical corporate field of cubicles is eschewed in favour of bigger, more useful communal spaces (such as the library), and small, efficient workstations. Those workstations are arranged according to the studio structure by which the firm operates. Polycarbonate partitions abound, sandblasted on one side, smooth and dry-erase marker friendly on the other.

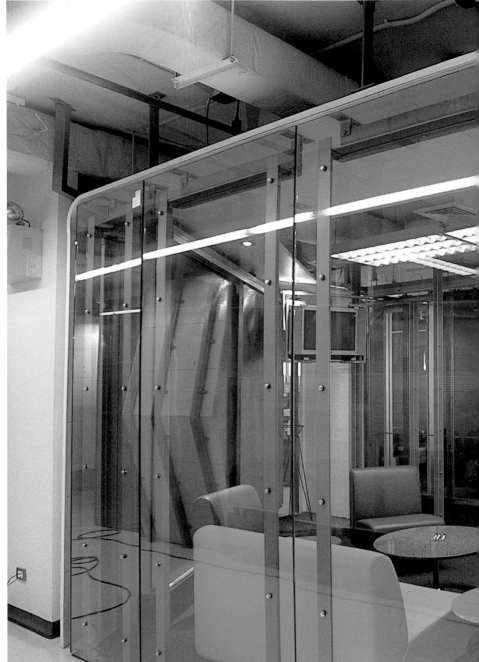

ADMINISTRATION & ACCOUNTING

11th floor
sc matchbox
co ltd

NAME OF OFFICE **SC MATCHBOX CO LTD – ADMINISTRATION & ACCOUNTING**
OWNER/CLIENT **SC MATCHBOX CO LTD**
ARCHITECT/DESIGNER **ARCHIPLAN CO LTD**
PHOTOGRAPHER **KELLEY CHENG**
TEXT **SAVINEE BURANASILAPIN & THOMAS DANNECKER**
LOCATION **PHAYATHAI, BANGKOK, THAILAND**

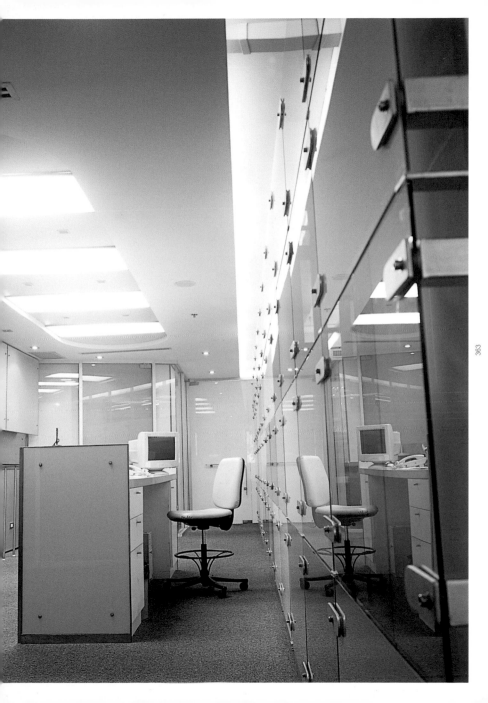

The 11th floor lobby of SC Matchbox's offices serves the Administration and Accounting Departments. At first glance, it might appear to be rather conventional. Shapes are orthogonal, colours lie comfortably within the overall palette of whites and blues, overhead lights are fluorescent. But look again. Each glass panel behind the receptionist's desk is a different colour of blue or white, with a different degree of translucency. The steel clips that hold them together are part of a comprehensive custom-designed system that incorporates every last detail, from partition connectors to door handles.

An important part of the unusual style of this office, though, are the things that you will not see very much of: yellow sticky notes, filing cabinets, messy desktops, paper. While SC Matchbox is not a completely paperless office, the nature of its business, workforce, and clientele is such that it really does not need very much paper. The mess created by paper, the space it consumes, the confusion it causes, the environmental damage, are being conquered here by an unusually comprehensive computer network.

Less paper means desktops can be smaller and tidier, but computer-networking equipment must be accessible. Eliminating the sketchpad does not necessarily eliminate the need to sketch, so walls can serve a secondary function as dry-erase marker boards. SC Matchbox is developing a working method that responds to the needs of its industry in the global marketplace. Its physical environment, more than just representing the company's corporate identity, is an active response to the evolving working methods of a contemporary office.

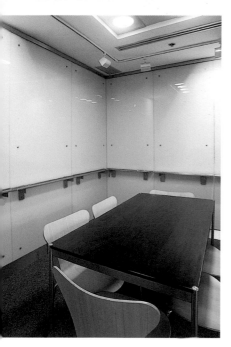

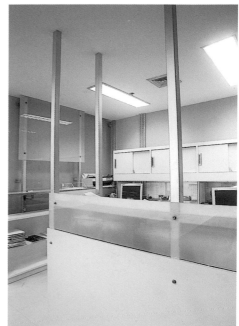

EVENT MARKETING DEPARTMENT

17th floor
sc matchbox
co ltd

NAME OF OFFICE SC MATCHBOX CO LTD - EVENT MARKETING DEPARTMENT
OWNER/CLIENT SC MATCHBOX CO LTD
ARCHITECT/DESIGNER ARCHIPLAN CO LTD
PHOTOGRAPHER KELLEY CHENG
TEXT SAVINEE BURANASILAPIN & THOMAS DANNECKER
LOCATION PHAYATHAI, BANGKOK, THAILAND

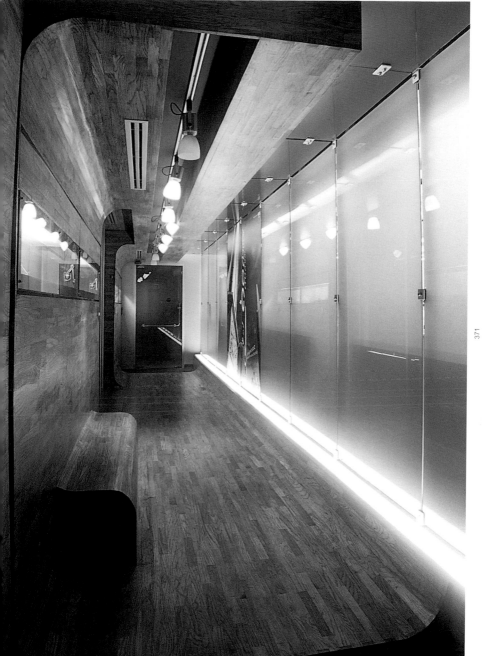

Floor 17 of SC Matchbox's corporate headquarters accommodates 40 employees of the Event Marketing Department. While their creativity takes a less obviously graphic form than that of the designers upstairs, the design of their workspace follows a similar principal, encouraging interaction between workers, innovative problem solving, and transparency of structure.

"Creating a physical image that would lead to a good public image" was the design task given to Archiplan in the project brief. Nowhere is this mandate clearer than in the 17th floor's small, dedicated lobby, which is rendered in the colour pink, glass, and wooden floorboards. Not constrained to the floor, the wooden boards gracefully fillet to change plane and become a low bench, a wall, and a portion of the ceiling. Glass occasionally interrupts the wood's migration, to reveal pink-lined lighting chambers. Artificial light reflects off of the pink surfaces and enters the lobby through the glass, only to be quickly absorbed by the dark wooden surfaces. The pink colour and the glass fill-out half of the ceiling and one long wall, saving the narrow lobby from becoming a dark, disorienting tube. The space is pure and clean, with no moveable furniture, signage, or decoration to clutter it.

The visitor, sitting in the low bench-cum-floor-cum-wall-cum-ceiling, would undoubtedly contemplate the lengths to which this firm is willing to go to project an image. The lobby has the richness of material and lighting that one expects from a high-end corporate office, but reflects the innovation on which SC Matchbox prides itself.

team·work /ˈtiːm.wɜːk/ (noun) : the work of persons acting in close association

A BOX WITHIN A BOX

sotheby's office

A small and simple space within a hotel courtyard successfully serves a not-so-simple function. This box within a box facilitates access to Thai art for the rest of the world, and access to Western art for local collectors.

NAME OF OFFICE SOTHEBY'S OFFICE
OWNER/CLIENT SOTHEBY'S
ARCHITECT/DESIGNER VITOON KUNALUNGKARN/IAW
PHOTOGRAPHER KELLEY CHENG
TEXT SAVINEE BURANASILAPIN & THOMAS DANNECKER
LOCATION SUKHOTHAI HOTEL, BANGKOK, THAILAND

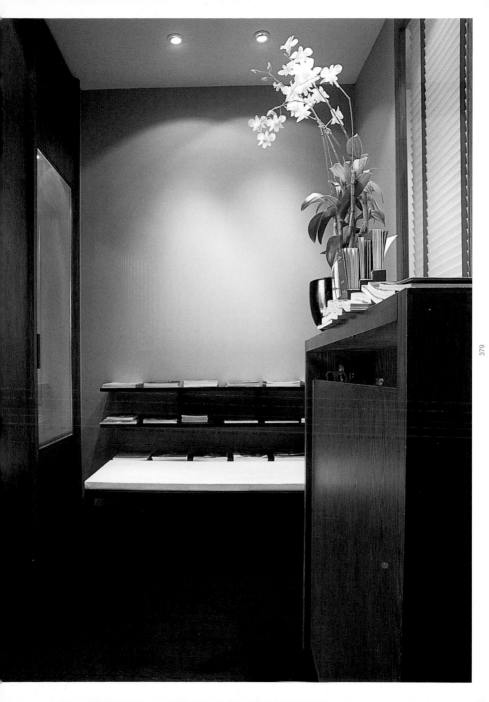

The Bangkok satellite office of Sotheby's is sited in one of the serene, quiet courtyards of the Sukhothai Hotel – a fitting context for an office whose role is to facilitate access to Thai art for the rest of the world, and access to Western art for local collectors. "Contemporary Thai" and "East Meets West" are cliches, but they are useful for attempting to describe the undeniably hybrid style at work here.

The architecture and interior design of the Sukhothai Hotel reflects the traditional Thai sequence of spaces. It simplifies and borrows some of its decorative motifs, and utilises familiar water elements in the courtyard areas. The result is an elegant, blissful, concealed oasis of tranquility in the heart of Bangkok.

Sotheby's Office occupies a miniscule space within the complex. Its parti is simple: one box inside another. But this small and simple space manages to service a not-so-simple programme. The wall of the outer box is thick, its poché filled in with storage and display cases. Some of these face Sotheby's interior, and others face the outside. The space between the boxes contains a reception area and a viewing gallery that wraps around the perimeter. The interior box holds workspace for two, but occasionally doubles as a meeting room. Its wall is thin, and easily transformed. It is made from a sophisticated system of folding glass doors with wooden louvres, so that its profile can be almost completely eliminated, turning the space into a single room.

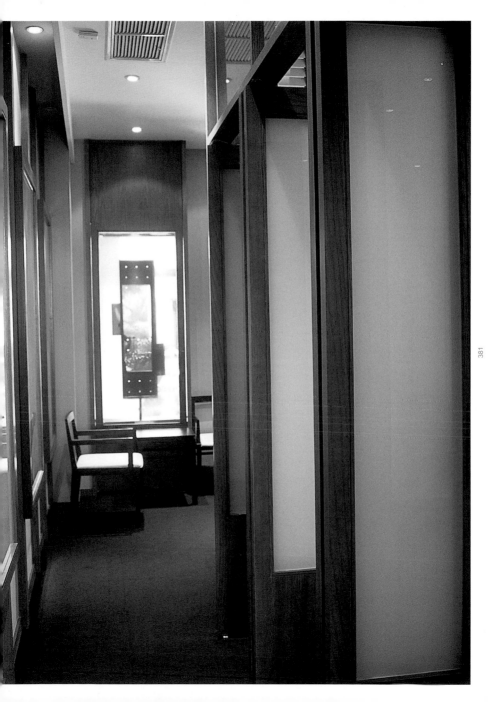

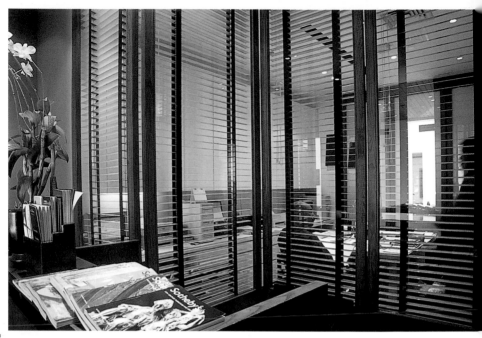

A WELL DESIGNED PACKAGE

tetra pak

Design studio, portfolio, and laboratory rolled into one by sinuous and slick display walls, Tetra Pak's offices are a model for what a corporate environment could be.

NAME OF OFFICE **TETRA PAK**
OWNER/CLIENT **TETRA PAK**
ARCHITECT/DESIGNER **ORBIT DESIGN STUDIO**
PHOTOGRAPHER **MARCUS GORTZ**
TEXT **SAVINEE BURANASILAPIN & THOMAS DANNECKER**
LOCATION **PRAKANONG, BANGKOK, THAILAND**

Tetra Pak is an international company that specialises in packaging design – a form of advertising with its own needs, and an ever-tangible output with concerns that are as much about ergonomics as aesthetics. Its Thailand office, by Orbit Design Studio, is itself a package of slick design. It is an ad-surfaced container, and its meeting spaces are designed to simulate, and are named after, the package-filled retail establishments: supermarket, canteen, and so on.

Meetings between designers, consultants, and clients mark each phase in the design of a package, and the entire office revolves around this multi-step process. Different phases and products place different demands on the architecture. An early phase meeting might involve a slideshow in a fairly conventional conference room, but later meetings are held in rooms that evoke the context of the point-of-sale. Having a supermarket shelf around is handy for designers as well, keeping them grounded in the reality of the market that their products are destined for.

This is not to say that Tetra Pak's offices are a purely functional exercise. Orbit Design does not shy away from revelling in the joy of display for its own sake. Virtually every vertical surface is a sheet of glass, a stack of packages, or an image of a package in use. Most remarkable is a corridor, infinitely repeated by a mirror at each end, with one back-lit wall that illuminates neat rows of packages, hovering on their barely visible glass shelves.

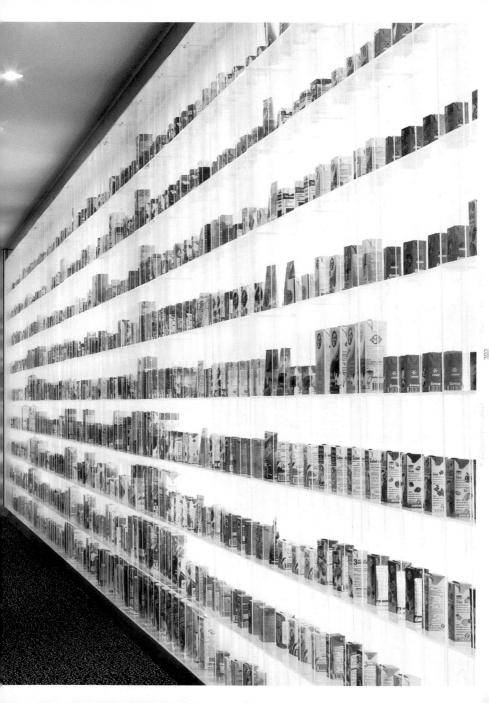

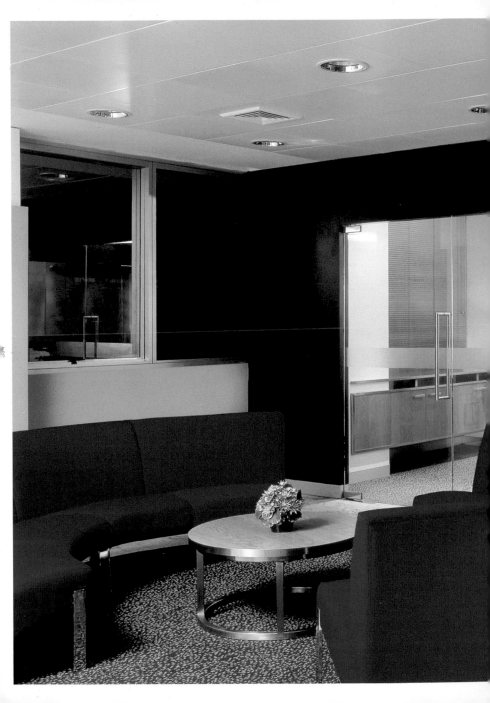

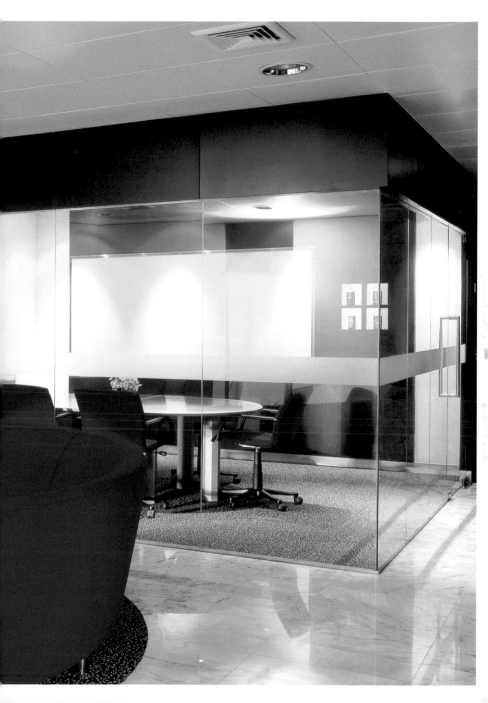

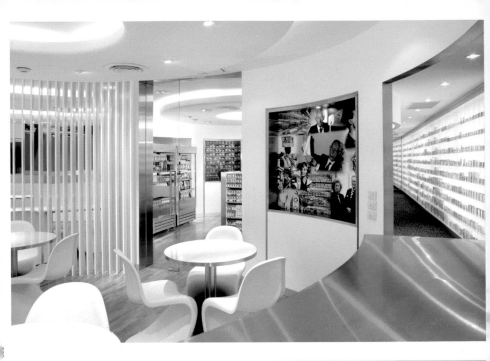

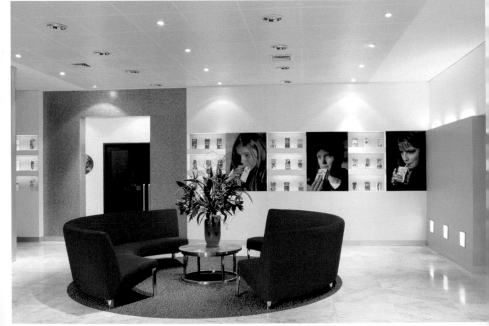

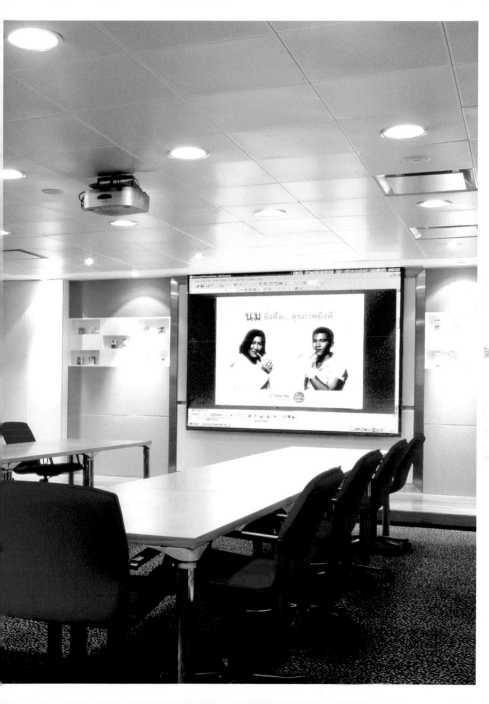

architects'
email index

HONG KONG

Atelier Pacific Ltd
atpac@atpac.com

CL3 Architects Ltd
william@cl3.com

Cream Design + Architectural Planning
info@cream.com.hk

Dialogue Ltd
info@dialogueltd.com

Edge (HK) Ltd
edgeltd@netvigator.com

James Law Cybertecture International
james_law@jameslawcybertecture.com

KplusK Associates
kplusk@netvigator.com

L & O Architects
hzimmern@leighorange.com.hk

M Moser Associates
MmoserHongKong@mmoser.com

JAPAN

Masataka Baba
nk3m-bb@asahi-net.or.jp

Myeong-Hee Lee
leecha@mue.biglobe.ne.jp

MALAYSIA

C'arch Architecture and Design Sdn Bhd
carch@myjaring.net

Unit One Design Sdn Bhd
uodc@pd.jaring.my

SINGAPORE

DDA (Designed Design Associates Pte Ltd)
designed@pacific.naet.sg

ECO-ID Architects and Design Consultancy Pte Ltd
ecoid@pacific.net.sg

THAILAND

Archiplan Co Ltd
newbreed@samart.co.th

IA Architects 49 Limited
ia49@49group.com

Orbit Design Studio
info@orbitdesignstudio.com

Rujiraporn PIA Wanglee, P Interior & Associates Co Ltd
pia@pia-group.com

Vitoon Kunalungkarn/Interior Architecture Workshop
iawbkk@asiaaccess.net.th

RAD in association with Edge Architects Ltd
info@edge-architects.com

RHK
fionahardie@rhkdesign.com

Sunaqua Concepts Ltd
sunaqua@hkstar.com

Woods Bagot Asia
wbhkg@woodsbagot.com.hk

Forum Architects
studio@forum-architects.com

Greg Elliot/Clear Consultants
greg@clear.com.sg

SCDA Architects Pte Ltd
scca@starhub.net.sg

Soo Chan/SCDA Architects
csk@scdaarchitects.com

Wice Open Spaces
woe@swiftech.net.sg

Woods Bagot Singapore
wbsin@woodsbagot.com.sg

acknowledgements

We would like to thank all the architects, designers for their kind permission to publish their works; all the photographers who have generously granted us permission to use their images; all our foreign co-ordinators – Anna Koor, Barbara Cullen, Masataka Baba, Kwah Meng-Ching, Reiko Kasai, Richard Se, Savinee Buranasilapin and Thomas Dannecker for their hard work and invaluable help; and most of all, to all the establishments who have so graciously allow us to photograph their offices and to share them with readers the world over. Also, thank you to all those who have helped in one way or another in putting together this book.

Thank you all.